STILL, THE SKY

ALSO BY TOM PEARSON

The Sandpiper's Spell

STILL, THE SKY

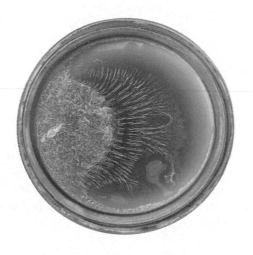

Poems, Artifacts,
Ecofacts, & Art

TOM PEARSON

RANSOM POET | NEW YORK

Published by Ransom Poet Publishers (Ransom Poet LLC), New York.

All artwork from *The Archives of Asterion*, a mixed-media art installation by Tom Pearson © 2022. In most cases, photos of the artwork appear actual size. All natural components of the artwork are found items; no bees, ladybugs, lightning bugs, birds, sharks, scorpions, plants, or other living beings were harmed in the making of the work.

Cover Design by Owen Gent

Interior Design by Tom Pearson

Editor: Anne McPeak

Still, the Sky / Tom Pearson. -- First Edition: June 2022

ISBN 979-8-4308954-7-1 (Paperback)

Library of Congress Control Number: 2021948302

RANSOM POET PUBLISHERS
NEW YORK | RANSOMPOET.COM

To our sacred quietude,
For us at the center of our labyrinth

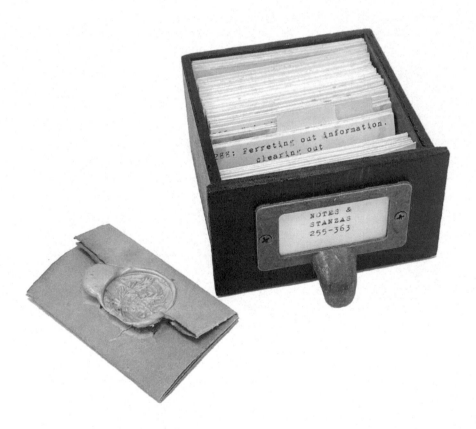

Fig. 1. *The Archives of Asterion, Notes & Stanzas 255-363*

Contents

Prologue: Waters That Know Our Names 15

I. **A Foreign Stillness**

Fragments of Icarus 17

Last Days 21

Waning 23

Senex 25

Prospect 26

Apotheosis of Ganymede 28

Summer Son 29

II. **In the Garden of Asterion**

Call to Prayer 33

Primavera 34

The Minoan 35

Cenotafio 37

Oration 39

Rite of Spring 41

Formicaio 47

III. Starboard

 Migration 51

 Tributary 53

 Carnival 56

 Interlopers 57

 The Garden 59

 Oracle 60

 Melody 61

IV. Riposa

 Farfalla 73

 The Raincarver's Palace 75

 The Stiltwalker's House 76

 Tryst 77

 A Walk 78

 The Holiday 80

 Protégé 82

V. Cartography

 Lazaretto 97

 Calypso 98

 Tension 99

 Clew 100

 After the Funeral 101

 The Vote 102

 Revisions 103

VI. **The Blessing of the Fleet**

The Night Fishermen 105

Story Stealers 108

Slow Storm 110

In the Cave of Minnows 112

The Second Letter 115

Archaeology 117

The Snail's Escape, or Growing/Old 118

VII. **The Name for Dreams**

The Rain Room 131

Dreams of War 133

Flight 137

In Memoriam 139

Daedalus 140

Icarus 142

Asterion 144

Epilogue: The Things I'll Miss 157

Notes on the Installation Art 161

Notes on the Text 163

Acknowledgments 167

List of Figures 174

About the Author & Artist 177

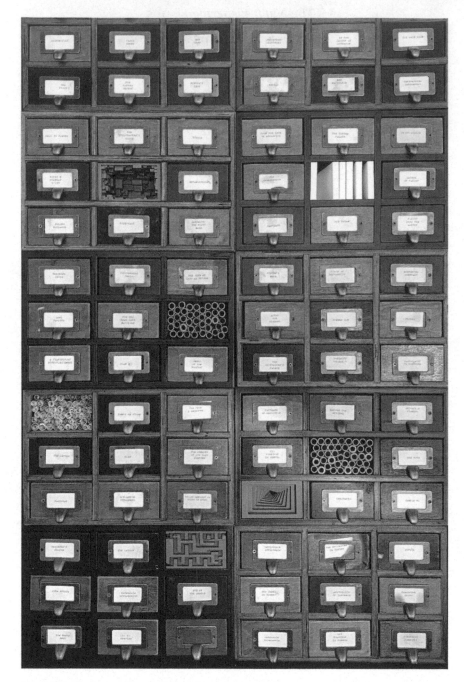

Fig. 2. *The Archives of Asterion*

Homesick for homeland, Daedalus despised Crete
And his long exile there, but the sea held him.
"Though Minos blocks escape by land or water,"
Daedalus said, "still, the sky is before us,
And that's the way we'll go. Minos' dominion
Does not include the air." He turned his thinking
Toward unknown arts, changing the laws of nature.

—Ovid

STILL, THE SKY

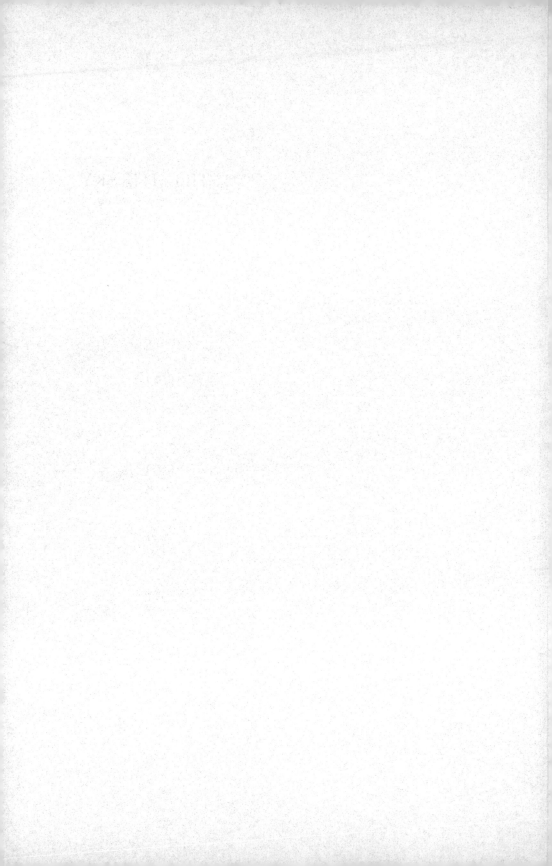

Prologue:
Waters That Know Our Names

My departure instigated his exit,
Longer, slower, more deliberate, the way
Of the sensitive, thoughtful and reflective,
 Even through heartbreak.

Storm clouds from the era of our grandmothers
Gathered over us, blowing in from the sea,
Mothers from the hills where on the lowest klines
 They'd lounge and listen

Then turn to night and a harvest of sorrows,
Pack for tomorrow to leave the land of our
Ancestors, exiled to waters that have seen
 Us a thousand times.

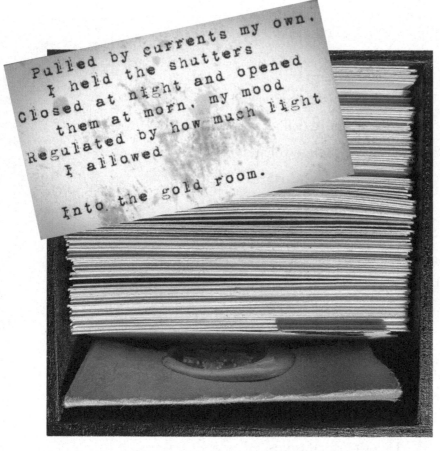

Pulled by currents my own,
I held the shutters
Closed at night and opened
them at morn, my mood
Regulated by how much light
I allowed

Into the gold room.

Fig. 3. *Notes & Stanzas* (set 1 of 7)

I. A Foreign Stillness

i. Fragments of Icarus

Let god folly and father fracture matter
Not, this immortalization, for us, a curse,
Constellations for others to navigate
 By what to avoid.

There was a great voice in my head the morning
After my death that woke me from sleep, whispered
Into my ear, *Get up, go—go write*, urging
 Me to confession—

To remember it not as a failure of flight,
Not for the fall, for the end of that life,
But for the tender years of sweetest youth spent with
 You, my childhood beast—

For treasures received, hidden in the garden,
Passing stories as we gathered wax and feathers,
Telling the tale and untelling it
 Soon as it was told.

Found then at last is this, our first stanza of youth,
An autobiography of imprisonment,
The metronomic distance between arrival
 And departure.

In the slatted daybreak, I witnessed, peeking,
Shadows in the garden and increments of
Color, light, and sound, which crept between the
 Attention I gave.

Pulled by currents unknown, I held the shutters
Closed at night and opened them at morn, my mood
Regulated by how much light I allowed
 Into the cold room—

Laying out ideas there upon twin beds,
Pushed together at night and boldly turned down
For a harvest inside of future dreams, for
 What was yet to come.

In the future, I will remember this:
The blessing of the fleet, a foreign stillness,
Cousins to nostalgia and melancholy,
 The passing lanterns

Of the night fishermen who poled and prayed
To hook a dream or spear a light under the
Suggestion of stars, once crossed, crossed again,
 Sewing up the sky.

And in the future, I will think of him along
A cartography of where his hands have passed,
Maps drawn on silk, hidden in coat pockets and
 Of his quiet stealth.

I marked days and a catalog of lesser
Innovations on the wall in an attempt
To record our evenings and think nothing to
 Look upon them now—

In the sea, more than before us, and in that
Effort to notate what had occurred in the
Night, more than nearer your promises, more than
　　The whispering waves—

More than Helios to hypnotize, with wings
Or sails, testing, if the gods did not come, we would
Become the gods, through flight and hubris, with a
　　Harness for the wind.

But our alchemy gained little from it,
Our movement toward freedom, plunged, swallowed by
Seagulls or marauded by marlin, angels
　　That swim, fish that fly.

Along the margin of the boundary layer,
Water chased wind, coupled currents clashed to
Appease the appetites of too many in
　　Every direction—

And your soul's energy, overharvested,
How I cried to leave you there, screaming in your
Labyrinth, and me aft, behind in the tailwind
　　Of my father's flight!

Such craftwork, left like a plaything for a child,

His carelessness, a sword, and in the future

I will think of him thus, a father asleep,

 A mentor surpassed—

A prisoner once caught, now a child drowning in

The sea. It was written by my own hand

Upon scrolls of the deep, this very love, this

 Passion for falling.

ii. Last Days

Fraternal order, their quiet solidarity,

Did not dissuade them from separating us,

Commencing a dialogue while dividing

 His profile from mine.

Worse, they blocked my view of his bruises, a rag

Held to his head, of his swollen eye, and the

Cuts on the bridge of his nose as he nodded

 To sleep in his hands.

I came to hold his head and wondered how

He arrived here, pleading to keep him awake,

But soon enough, left him as before on

 The path he knew well.

Resting yesterday, I dreamed him walking through
The garden. I dreamed him, dreaming me, now as
I walk the sullied streets and ravaged pathways,
 Observing his work

Of the night before, and though feeling sorrow for
His state of mangled fleece and outrage,
I understand that I am the one alone,
 Becoming extinct—

The price of our rich bounty, this long famine:
Paramours of shadow, a brother taken,
A father's right to rule and his bequest of
 Carnage, your birthright.

Each step I take without you, the contours of
My own rage are softened by lamplight against
The work you were enlisted for, to enact the
 Bloody sacrifice—

To be at one with each one buried, below,
Finding your scribbled notes and reflections left
Above on mantles, my wings struggling with the
 Altitude and wind—

Dividing up our living space, finding fault
Lines along the floor, holes in all the walls,
Inaccessible geographies, oases,
　　　And subdivisions—

Beyond the green threshold where we once lived,
Riches you hid, and me street facing, trapped in
The remains of what we allotted in the
　　　Divvying of our lives—

Moving in an arid desert full of bones,
Sinking in a quenchless ocean, felled to bones,
Calcifying in the ruins of our prison palace,
　　　Your maze built of bones.

iii. Waning

To the others, note, a redacted affair,
Illegible on the evening his sea chest,
A heart once open, broke at once, livid white,
　　　Whistling to himself—

Tottering and lingering on the taste of
So little company. He cried out, but he
Would not speak when spoken to, and so
　　　I left him alone

With his unruly tongue and with his sour
Disposition. It did us good all the salt
We saved that summer, the taste of ambrosia
 On our purple lips—

 The summer before the gardener brought his
Note to me in the shady afternoon,
But knowing his occupation until dawn,
 I held my peace.

 The investigation of the late season
Was like a sunset, with his hot temperament
Changing with the changing daylight, and as the
 Days became shorter

 So did his shadow shrink until it cast no
Longer around the edges of the tower.
At first cold, he was no more though the story
 Went from first to last.

 It belongs to me now, forever, and only
Thereafter in the silhouette of the
Night theater, all these riches unseen,
 This prize, unlifted.

A father's word turns with the tides, coos like a
Child in adult conversations, listens to the
Protest of peacocks and renders their language
 To us decoded.

Those he sheltered in the gathering, clipped and
Caged, reached for their freedom with talons sharp
Enough to arrest creation from Creator
 Before his work was done

And the cruel task complete, to make something of
The air and condemn it to the ground. Later,
Seagulls made nests in each corner he blockaded,
 Until fledging, fell.

I waited to enter through an arch along
The breezeway, the one window I had into
A gentleness in his heart, a story for each
 Feather we gathered—

Learned of him in shadow, tales told as asides
To lighten the tasks we toiled in winter, until
The nest was full again in spring, one less death
 In the family.

The old skittered 'round the garden wall

Protecting the new life so painstakingly earned.

The honey on our lips from bees who cross-

 Wind along back roads

 Inoculated us against the pollen

That dropped along the ash's hemline, blood of

Heaven, manna of stars, dead-fallen here in

 A snowstorm of spring.

 It kept us running on a river of tears,

Covered our conveyance with a fine yellow caul,

An unruined world that held both the venom

 And the antidote.

v. Prospect

 In the oration of heroes and gods,

We were immortal in their way, could survive

Our disasters, pass through our deaths. We had the

 Resilience of youth.

 Floating along the wake of water, beneath

Stern warnings, we towed as near to shore as we

Could muster, careful not to run aground of

 Previous mistakes.

Seven or fourteen or more, anything
Less and we were undone in our own way,
Lasciviously bothered by the sport of
 The hunt for those here—

Clouding the waters with wantonness and a
Fuzziness over their own potential, with
Nature upon their shoulders, on this ground where
 Mortal men stand fixed—

The tiny troops forced to proceed, caution for
Fear, their mission before them cast to the ground,
The sentinels of the labyrinth's reveries
 From which we set sail

From the docks of prospect, running up the masts
Of first discovery with something later
For our pains. In the sea his voice obeyed the
 Breath of the moment

And swallowed up him whom the gods made to play
Therein, a creature that I have loved as my
Own, and on that day, he spread his wings and flew
 Out over the sea.

His teachings rendered us neophytes, budding
In desire, clinging to an arm with
Aspirations vital as a row, for the
 Fight, wrestling our own—

For my own conundrum, the propositions
Of Helios and Poseidon, revealed now
By one Icarus of Crete and Candia,
 Who held a monster—

Not tall nor strong but beautiful against the
Specimen of Ganymede, honored for
Effecting the perfect proportions idealized in
 That society—

Lifted top to tail to Zeus, he would what I
Could not, such futility, resisting the
Seductions of rising and falling, courting the
 Depths of sky and sea.

They rest unevenly, canyons from peaks, the
Underworld written not against heaven's height
But for descent, not a god wish but for death,
 A new beginning—

To destroy us while we create them again

In our own image and occupy their seats

For some time. It is in the descent again

 We thus reconcile—

And not in the apotheosis of the

Cupbearer to quench a jealous god, but in

The passing of the mortal and monster

 Back into god form—

Given wings at the beginning or end to

Escape this tower on feathers or fins, not

As it was prognosticated to us, we

 Rose in the gloaming.

vii. Summer Son

Pesce volante, its entrails left gutted,

Impaled, skewered, then finished, retractable,

The separation of flesh, the skeleton

 Of the flying fish—

A foreign stillness suggested a change,

Smashed like rotting apricot, tasted honey from

Lying lips, felt the sour circumference of

 Adulterous hips—

He was your grandfather after all, beaming
His all upon us, watching each step we took,
Luring me to kiss his face in the sky, then
 Setting on my fall.

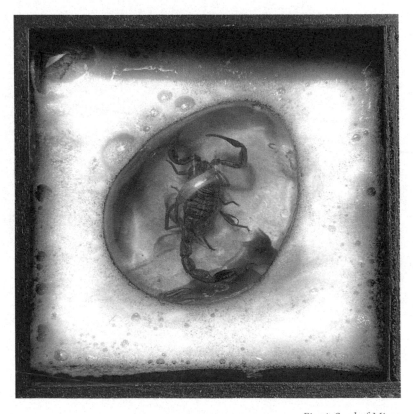

Fig. 4. *Seed of Minos*

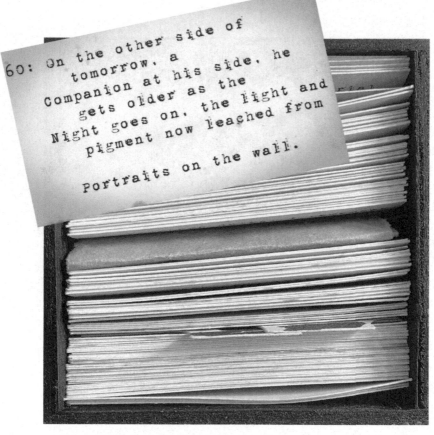

60: On the other side of
 tomorrow, a
Companion at his side, he
 gets older as the
Night goes on, the light and
 pigment now leached from

Portraits on the wall.

Fig. 5. *Notes & Stanzas* (set 2 of 7)

II. In the Garden of Asterion

i. Call to Prayer

There was, in that time, an affliction that spread
Through the realm, brought forth by the atrocities
Of a king and his inventor, gifts from the gods
 Turned to punishment.

All the times I called your name on a
Red-tide morning, we lay in shelter
In the death embrace of this
 Recognition:

There was no safety in our maze of solitude,
No view enjoining the land to recognize
Some split along the river that now empties
 Into this canyon.

 Crossing the threshold, a call to prayer,
The sweet smell of apple tobacco raised
A swirl of smoke on sunset, at every
 Turn, a companion.

 I saw them embrace at a distance, through
A keyhole, far from Athens. What was this
Place, with so much vapor over my disguise,
 You could not see me?

 ii. Primavera

 And the seventh boy at daybreak watches now
From the last corridor of a spring blizzard,
Poplar snow blossoms gather at the edge
 Of the labyrinth—

 And the heart wants, Star Boy and the dawning light,
Daedalus, the usurper of blessings, some-
One else's invention, someone else's accolade,
 Infidel pollen.

From the more distant rampart, a vague regret,
A perfunctory acknowledgment, a time
Before the push, before the fall, a time when
 We knew no ending.

And the heart wants flesh in the Garden of
Asterion, a task to complete now in
Silence or solitude, unheld by these walls,
 A dream of exit signs.

iii. The Minoan

He was not a father then but a warden,
Preparing me as oblation to a father
Far away, sent to solve some mystery
 That puzzled the king—

A leader who won wars by his willingness
To sacrifice the most of his ripe young men,
His sweat mixed with apricot, diffused in the
 Presence of his fear.

The first blow he landed was at fourteen.
Wetness, with its metallic odor, smelled like
A filthy floor someone had cleaned in a
 Rush, lye over wine.

Fallen from the mount, from a fight with his
Own father, down from Olympus, tumbling,
He made a pattern in his arms
 For a boy like me.

 Ready-made to take his place, Hephaestus turned
A fiery forge, manipulated with rough
Hands its convex contours, its proud protrusions
 Stiff with clarity—

 But soft inside the mold that would carry the
Forging metal of the other hardening,
Pouring into another with gentle,
 Sacred alchemy.

 To murder the terrible music but keep the
Melody maker alive, you required nightly
Tribute, and now Dreamgiver provides
 Nightly remedy.

 But then, the roles reversed, picking up the tale
While the other sang a verse, we lowered ourselves
Into the feast, anointed and adoring, with
 Another of your

Songs to soften the blow, to fill gaps

In the mortar where your fists later made

Bird's nests in the walls, time filling in meaning

 With its own story.

How would we have known if we had not stopped

To watch the wrens the day their father returned,

Rousing them early from sleep to teach them how

 To fly, or how next—

As you held me tightly against the stone wall,

He taught them to care for themselves and feed

And forage in the lower temple grass, and

 Satisfied, they fledged?

 iv. Cenotafio

Each time one fell, I forgave him the shattering,

In turn, devoured by a being whose job it was

To swallow shame, eat the sins of his father,

 Consummate each death—

Innocence, with new wet down and wings unspread

Taken from its nest, left by its ward, a

Penance paid to the state that supported this,

 Our dark endeavor—

Sent to judge a creature who had not
Consented to the abomination that forged him
From sea foam, crossed the line, stood before
 The court of Neptune.

 They sang odes to the failures of gods and men
And saluted the places that we would
Never go again, Troy or Damascus, not
 Until this war rests.

 I walk them now without him, a voyager
To the homeland, though I cannot cobble any
Semblance of meaning from these stones on
 Such sanitized streets.

 He invited himself, an accidental
Member of the procession, each time he sensed
I had a value, moving in closer,
 Aimlessly floating

 Along the gray hull of my shattered bones he
Laid to rest, so Herculean, upon stone,
Draped over them a watery shroud so that
 They might see my wings—

In splashes of crimson and green, iridescent,
The feathered outline of a shrinking silhouette,
Desiccated, seeping, swallowed, earth drinking
 Deeply from the wounds.

Somewhere on Icaria, a reminder
From launch to landing, cairns of my passage,
While I sit alone at the desk of my years
 Writing this to you—

My confessions on cliffsides, holding up
The bluffs of Italy, far to the north of
My grave and a father who made it as
 Far as Sicily.

v. Oration

Silent listeners, trees bent at the waist. What
Was said in the street was heard in the grass, a
Voice threatening, *I will kill you if you speak*, and
 I opened my throat.

Safely interred the time he presented
A lecture at the Acropolis, holding
The attention of travelers and locals,
 We first stole away

Into the night and into the baths he had
Made only a short distance beyond precious
Time-When-Stolen, Parallel-to-Noise, our own
 Sacred quietude.

Out of bounds, piercing through
Expectation and a counter to his speech,
Judged by the first man we loved, when we learned to
 Recognize his face—

His denial our greatest heartbreak, without
Knowing, shunned, without consultation, condemned—
The course we sail with all others, set by that
 Paternal neglect.

Then, hearing the rumblings of applause, felt fear that
Someone might our absence note, and sense within
The crowd, trembling with excitement, the color
 Of mutual threat upon us—

Our expressions to each other, still
They acquiesced, more profoundly driven to
Completion, maps written within our bodies
 By those before us.

We were grown inside nostalgia, in refuge,
Through forced arrival where we became the first
Generation naturalized, betrayed in
 A conflict with Neptune.

Unable to account for the mounting losses,
For mothers, fathers, mentors, god temptations—
Genius, still, we played in the maze. We loved
 Obfuscating it.

The miserable children of those committing
Atrocities we couldn't comprehend, yet
Imitated these, and when we hailed the spring
 They arrived again—

Ships sailing in for the blessing of the fleet,
Leaving their sacrificial obligations,
Seven and seven, playmates for a season,
 Tribute thereafter.

After the first of seven was plucked for the
Feast, the others would set up camp
Around the twists and turns of the pathways,
 Chastity-in-residence—

And they would plot to meet and spoil themselves,
To love the murder away, but they were kept
Apart, running from the gaze of the creature
 Whose shadow you cast.

It was our universe, the portrait of you before
Silence grew us, when not knowing held wisdom,
First confidant, first betrayed, you who ruled this
 Fragile fantasy—

With the flourish of your outbursts, tantrumed your
Way, annihilated all in your path, slammed
The garden gates, settled your father's accounts
 In the rite of spring.

With you in a hall of mirrors where neither
Of us exist, part of me is still trapped with the
Only part of you I can remember,
 Past what I can see.

As far from home and as foreign as I was in
That false-face place, the turret curated a view
Of their wealthy and unworthy tourism, our
 Deep dives, marked for show—

Assaulted with questions that tangled us in narrow
Squares and triangles, in its foul geometries,
Blades that spun when that awful sound rang out
 (Then moved, stopped: scene change).

 We are over center, moving steadily,
Hovering above the fray, in calm and
Quiet, in relationship to the back roads of
 Our time together.

 The older we got, the further we ventured,
Those known or remembered grew fewer, our
Mythology to go late, go farther. Our
 Power surged with age.

 Marble gave way to forest, and you failed in
A different orientation to it all, knocked
From our shared axis, an unknown effect,
 A memory lapse.

 (How old were we then? Did we drink wine or mead?
Or were we still drinking the juices of the
Apricots and peaches? The mystery man,
 What did he offer?)

How did we find our way to him without the
Signs? The lure of the place and our journey there,
But the span of a few months, stretched instead for
 Years in their meaning.

 Ecstasy at the distance I could travel
Between catastrophes, a bright, brief acumen
That caused me to cover so many years,
 In those short visits—

 In search of a trace of you amid the ruin,
To know you in your vanquished, unexamined
Reluctance, a discarded undergarment,
 A hair within them—

 Something I could conjure you with through
Scent, a familiar cover, the veil between
Something erotic and its more sensual
 Predecessor—

 A talisman to allow an impossible
Intimacy, even now, just to know one
More secret thing about you and the universe
 Of who we were.

Resting together in that illusion of
Safety, she watched from afar, behind her
Observant mask of acquiescent regard,
　　　Yet to be involved.

　She knew my mother, the inamorata
With the black horse. I envied her foreign
Sophistication, and that she could touch that
　　　Which I could not—

　Though her father (your father), and my own had
Lain with her in turns, we might be some strange
Trio of siblings if not for the fact
　　　Our stations were such.

　I was still consort to a monarch whose wine casks
We refilled with well water, while you roamed free in
The prison he built for you. How we nearly charred his
　　　Quarters at sunset—

Before nature sounded her evening cricket calls
From the deepest ditches on the forum side!
We stopped, silent for his footsteps, while I envied
　　　Night its blackness.

But your music filled those afternoons. Your words
Kept company with me in quarantine when
I looked out at morning but could not touch
 Its radiant brow.

 In the lazy afterglow, rods still smoking
In our hands, while they took turns with our mothers,
We took ours, in turn, with one another as
 She wound up her clew.

 Even then, you were busy collecting
The relics of our time, the pieces of us
You would archive for remembrance, already
 At peace with the end.

 I forget the word she used, but it sounded
Like a condemnation, a slur she would
Hurl to grab the attention of passersby,
 Warnings tinged with pity.

 They would spit and turn their heads with a smile
On the other side of their faces (you brought
Her with you, such complicated company,
 And heeded no caution).

Coping with passions we weren't allowed to know,
We'd reach for them all the more such times a
Handsome figure would cross the stage and give a
　　　　Name to our longing.

　　　　　　　　　　　　　　vii. Formicaio

Running our fingers around the new year, we
Drew lines and circles in the pathways of ants,
Interrupted scent trails along a cypress
　　　　Stand, knees in the air.

Momentarily setting forth, we waved a
Hand of confusion over their day, to sense,
Observing as we were, the many eyes open
　　　　In the distant dark—

To see, the watchers watched, one-eyed ravens
Squinting sideways, scorched sentinels looking away,
Pissing by the roadside and watching it rise
　　　　In vaporous waves.

Their eyes and ears perked up in no man's land,
Spies on the move, interceptors eavesdropping,
Codebreakers, message makers, to touch, waiting
　　　　In coldest winter—

They cast the darkest shadows over the
Tiny hearted and ceased playing their drums,
Concentrating all breath held in the body,
 Listening for signs.

 That way, to feel the warm skins of the first fruits
Of spring, fallen near the stone's edge, walking in
The footsteps of another day while smelling
 Their putrid decay—

 Berries amid sandstone, dust again to taste,
Passing a walk together without notice
To the seams of our shadows, to feel something
 Burning in our minds—

 Eruption of ash upon our commitments,
The great ambition of another era,
Flowers before stone wall, roots clinging tightly to
 That within their reach.

 On the day of reprimand, we watched an ant
War in the plaza, a fight for territory,
Nurse ants collecting the wounded and dead,
 Adding up losses—

Then joined the spectators at the arena,

Demanding blood from the battle, no thought

To what winning would cost the gladiator

 Or our future selves.

We were grown in barren
 fields, reaching to
The hidden, judging its
 value by the way
In which it hid, tracing its
 pattern inside

 Its reclusion.

Fig. 6. *Notes & Stanzas* (set 3 of 7)

III. Starboard

i. Migration

Centuries later, we found ourselves again
Within the Veneto, but now it had its
Name, islands strung together in a design
 Without architect.

Quietude turned to percussive walking, a
Manicured alcove opened, remembered, once,
Or imagined, could, impossible still
 But for the other.

First sky, migrating geese danced on the lagoon,
Countless in their ritual display, turning
And rolling, over, water, back, standing on
 The edge of blackness.

Watching them watch one another in their
Feathered glory offered a view of you preparing
For winter and a longer flight where we
 Danced around logic.

Less than before, on a day when neither of
Us had gotten enough sleep, we moved in stealth,
Afraid to utter sound, needing a clearing
 To run free of it—

To stretch out our flailing arms for balance once
More before they failed us, to glide without legs
In slow gratitude, not weeping while the sun
 Shone on holiday.

In a wood with you, avoiding small children,
Avoiding animals, we picked peaches and
Watched for serpents, evaded mortality.
 You clipped verbena

And asked, *What is it?* Then into a village
We wandered, with time and no plan that night,
To visit a market in the early evening
 And dine in quiet.

Yearning still to gather flowers and to hold
The things you wish to hold, collect the things
You wish to keep, I mourn this softer aspect
 Of our lives together.

After a nightcap, we parted from the alley
Where we'd settled, and I walked home alone
In the fog of indecision while you went
 Forth to meet your mark.

ii. Tributary

Other matters hooked our attention along
The pathway we walked, the border of Father's
Ancestral arsenal, the Venice before
 The Venice we knew

Brought you to me by water one summer after-
Noon. We wandered in two directions, searching
For lost canals and found ourselves in
 Its puzzle pieces.

This was long before the others arrived to
Write and paint and sculpt its unwieldy secrets.
It was our game away from home, this something
 At once familiar

 In its rebellious logic and comforting
In its winding disorientation, a
Labyrinth my father might have outlined
 At his worktable.

 It echoed the way our imaginations
Worked together back home, in trio,
You, me, Ariadne, our shifting tones
 Showing the way through.

 She came forward with a new love, and I showed
Theseus my writings while angels followed
From behind, Father unsheathing a sword,
 Meddling in our affair.

 I knew I'd been there before on those marble
Steps, the pantry facing the courtyard, while he
Waited and I followed, hot in the night,
 Back to his room.

Conscripting each other for the task, we shared
In the manufacture of our own downfalls,
Jealously coveting each secret thing, un-
 Covered as we went.

Power rising, righteous indignation,
A vengeance that poured forth through clenched teeth
At the meeting of the twelve patriarchs, I picked up
 My sling from the foam—

And I spoke to all of the long road we took
Here, each step, each choice, each happenstance,
At council, spoiling the spoilers, telling them
 Of tributaries—

All the other stories, a ripple among
Ripples, taken to the sky, to the god of
The next planet that rides on my shoulders,
 But there were witnesses.

The masks on the wall, they knew. They saw. They spoke
To you at night and asked, all together, they asked,
Who will you take if you can take only one,
 Just one when you go?

Saying, *No, no. You can choose only one.* They
Spoke all night long, together they asked, *Who will you*
Speak to then when you are back in the lonely

 City, forgetting?

<div align="right">

iii. Carnival

</div>

 His eyes showed the canal reflected, siphoned
From the city in late season, inverting
Our attention. Our countenances tossed red hearts

 Upon a flat whiteness.

 Alpha to omega in a deck of all
The possibilities, and the carnival
Unfolded, reshuffled us as we drew an

 Ace on every side.

 He placed me inside a wooden box carved
Of temple yew, secrets folded into parts,
A quote and an image drawn on the burnt edge

 Of an olive leaf—

 A sepulcher filled, letter by letter, with
Sketches and seals, mismatched hearts, and the relics
Of our early years growing up together,

 Waxen lips apart.

Already the debt erased, the injury
That tethered it to the mainland, severed, cast
Into the Icarian, floating now like
 Danaë and child—

Until it reaches some fertile land and has
Resurrection on the shores of Seriphos,
The unfathomed and undreamed, the contract of
 All now forgiven.

iv. Interlopers

Treachery in the tall grass shielded its prey,
Offered us protection without perspective,
Life below the trod of footfalls, our own steps,
 Thunder to the ants—

The sky above made visible in the slow
Outline of marbled veins, the rocks, a map for
The migration route of geese along the cliff,
 Reflecting low cloud cover.

We simmered like a pan of oil, the truth
In that wavering heat, obscured as we were
By the present, blocking us at eye level,
 Trapped for who we were—

Severed where we resided, layer upon
Layer, persona upon persona, peeling
Back our skin to abandon or to trophy
 Onto our backsides.

We were grown inside nostalgia, reaching to
The hidden, judging its value by the way
In which it hid, tracing its pattern inside
 Its reclusion—

Talking all night long, or silent, unable
To stand up to the fear that made them hateful,
Armed with so many weapons and stones piled
 High in the hoarding.

How could we be held, Naucrate, Pasiphaë,
Left with no mothers to unscrupulous fathers,
Our early days filled with bodily pain,
 Cowering in fear?

Mothers' milk withdrawn, fathers' care deported,
Lack of acknowledgment veiled his soul's purpose,
Death shrouds over his originality
 Placed like prayer flags—

Threats of annihilation and genocide,

Subsistence embargoed, vegetables rotted,

Ancestral fear, sour fruit, and a silver sword

 Shining in his hand.

The separator of what lives and what is

Transformed, your domain, your acquiescence,

Which offered a new chrysalis in which to squirm,

 To wrap my nights in—

All gave over struggle, to release in the

Arms of another. Theseus bloodlet onto

Paper the plan for our destruction and

 Left when it was done.

v. The Garden

Beneath the city, our clandestine gateway,

We held up the dome of our own world inside

An opening we could squeeze ourselves through

 And escape the day.

We were granted safe passage and safe return

Where we built no fortress, no castle, nothing

To protect us from view. Seeing each other

 Across continents

Of failure and disappointment, feeling the
Intrusions of rising and falling and looping,
I spun around his axis and browned myself
 Against a star—

Spinning, falling, rising, sinking, aging now
In this sisterland, taking back the clew she
Gave him, older than Ariadne,
 The way back to us.

vi. Oracle

She draws me to her chair and redirects my
Embrace, sits beside me, taking me into
Sunlight. Others follow us as she refers to a
 Dream from last season.

I had known her in this wooded forest, asked,
How much did they pay you for your dream, for this
Arboreal service? and the other young
 Boys gather 'round.

She laughs, and they wonder what is so special
About this ragged youth that looks into her
Eyes without flinching, and they say to her that
 I am a delight.

Make yourself smaller than minnows in tide pools.
As you diminish, in time, so shall you rise.
What is seen from sky will be known first from the
 Pressure of the deep—

A circle of dragonflies above her, a
Murmuration of starlings above the
Dragonflies, a comet passing over them all, so
 Many layers of flight—

What is broken in him will be broken in
You, so make yourself as small as you can in
This time of danger and scrutiny so that you
 Might see in the dark.

vii. Melody

First small death, like so many ripening at
The taurine hands of the Minoan, came for me
At fourteen. Like his seven and seven,
 He played lute when done.

Red, hot, I could feel his blunt right finger pads,
Calloused, as he held my head against the stones,
The nails of his left talon, his melody
 Fingers at my throat.

A curtain of night fell to voices calling

My name as they entered the temple courtyard.

By the time I awoke, slumped on a stack of

 His scrolls, he had fled.

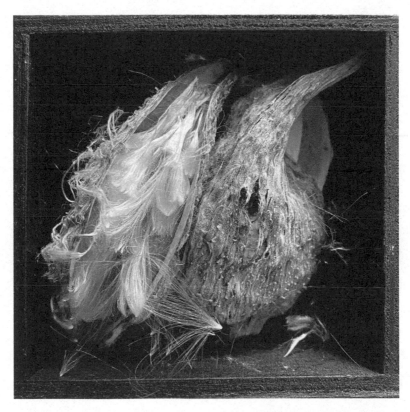

Fig. 7. *Gardener's Choice*

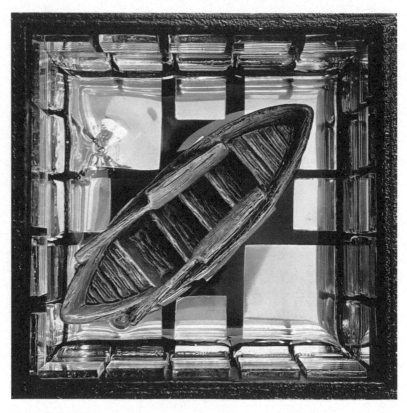

Fig. 8. *Hall of Mirrors*

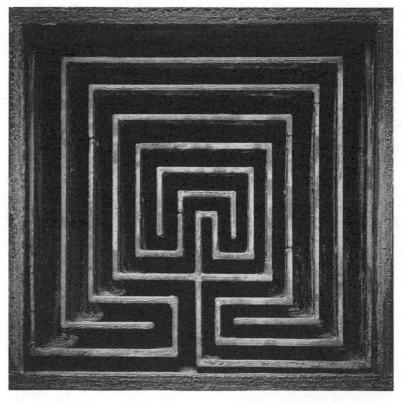

Fig. 9. *Obfuscation*

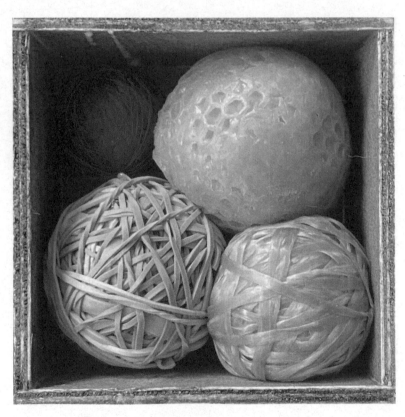

Fig. 10. *A Perfunctory Acknowledgment*

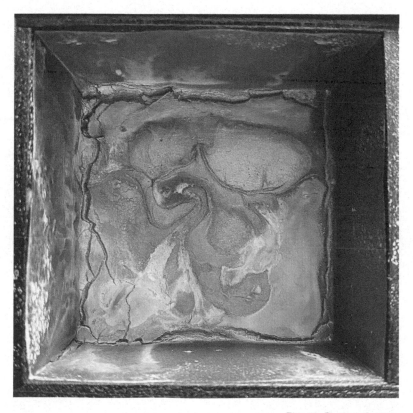

Fig. 11. *Prognostication*

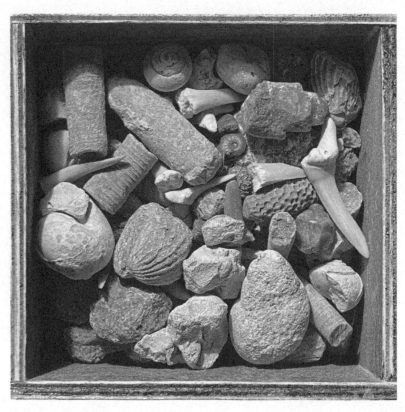

Fig. 12. *The Dig Near Lake Maggiore*

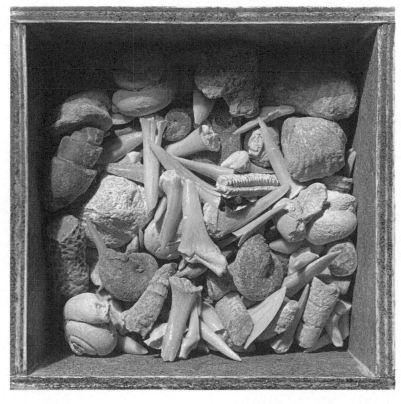

Fig. 13. *The Dive at Lago di Ripola*

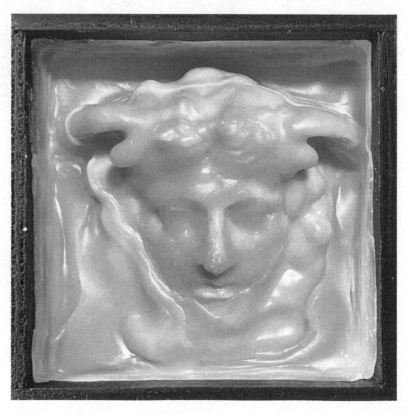

Fig. 14. *Wax Medusa*

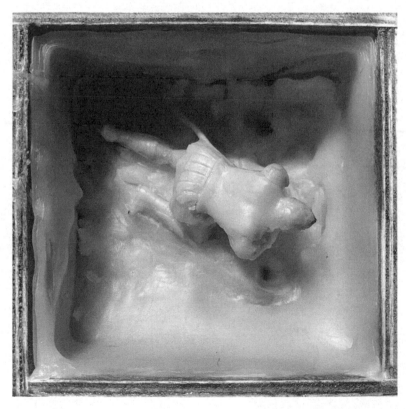

Fig. 15. *Wax Theseus*

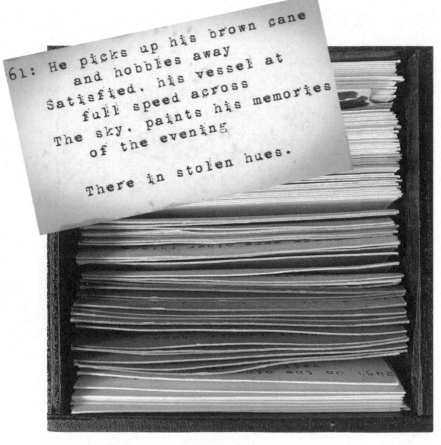

61: He picks up his brown cane
and hobbles away
Satisfied, his vessel at
full speed across
The sky, paints his memories
of the evening
There in stolen hues.

Fig. 16. *Notes & Stanzas* (set 4 of 7)

IV. Riposa

i. Farfalla

Along shore, through the groves of off-orange,
Support arches bonnet over our tiny
Ripeness. Chasing butterflies, I step on
 Yesterday's tragedy—

Putrid peaches rotting on rain-damp ground,
Relishing the squish of their acrid smell while
Ravens caw to each other across the hills of
 The Acropolis—

The corpses of the fallen, never reaching
An intended, the stench of decay and
Nourishment, together on the indifferent
 Mudlusty hillside.

We walk to untangle, to tell how it has been
To love this Gordian place and the stories
It ties itself up in, the comedies and
 Tragedies we seek—

Simple verse, sublime code, so natural
The testimony in all its stank, in its
Sculptural play, its blinding need, and its
 Colors splintering.

A deep-throated resonance of the sonic world
Of cicadas and cocks and seagulls, mingling
Their voices through the late morning, go silent
 As we pass by

And resume once we've been observed walking on.
Sex again on their minds, sex, then caution, then
Sex again, life's appetite puppeteering the
 Players on its stage.

With the father gone, the boy sent himself into
Dreamkeeper's care, telling once more the brief
Story of the inventor and child, imprisoned
 For the father's crimes.

Inside a tower of rain's impressions, seeping
Through stone, drip stalactite instructions and
Plans of escape on waxen wings, feathers
 From the birds he loved—

Mineral-rich in remembrance, gathered
In puddles on the floor, only this advice:
A warning not to go too high or low, not to
 Touch the sun or sea.

Unmoved, but with a measure of comfort and
My own bull keeper's patience for this man, *Yes,*
Keel his even course through uncharted sky, but
 On ahead he flew—

Unable to correct miscalculations,
A turning point in an ocean's eddy and
At last, to see a son who veered off course, who
 Lost sight of his aim—

And not of hubris, but neglect, from the one
He admired most, and the rain continued throughout
The long season to rock him into half-sleep
　　　　All of his days here.

iii. The Stiltwalker's House

Timelines along the crown molding reveal the
Handprints we left as a map back to our small
Selves, peeling wallpaper, misplaced keys, and
　　　　Bones within the wall.

Daydreams after an allergic reaction
To the oil that carried your fragrance, I scrubbed
Hives on my hands and leaned back to pass time at
　　　　The Stiltwalker's house.

I awakened in the afternoon to the
Buzzing of bees above slumber, everything
Gone long, my vertical connection to summer
　　　　Turned on its side.

Carpenter ants walked the back curve of my leg,
Carrying their spoils over my peaks and valleys,
And they danced me in sunlight while the
　　　　Scholar made his rounds.

On the other side of that wall, in your back
Room, the back part of myself and the hidden
Window opened on a stair, a messenger
 Waiting in rain.

I chased him through the corridor to the front hall,
Onto the marble steps, so that he might
Deliver a letter from you to me from
 The day after next.

It said, *Remember always, in all matters,*
Everything in between anything we do
Is what becomes in the doing, a habit,
 The next story told.

iv. Tryst

Heavier than regret, a loneliness came
In unannounced with a key dropped in the street,
Presented that part of itself to me, his
 Shy malevolence.

Inside my habits, looking for traces, it
Sniffed around the quarter and turned away.
Aroused, I covered the evidence with my hands
 Under the linens.

He received the telepathic message,
Returned it unacknowledged, then later sent
A message of his own, showed up smiling at
 The foot of my bed—

Uninvited but staying, attempting some
Comical thing, in his own way, coming in
Through secret passageways in the interstitial
 Hours as they slept—

Always at a bad time, saying, *I need to
Be fixed, now,* with one hand behind my head and
Another on my neck, crying at its end,
 Sealed shut, then vanished.

v. A Walk

Our vision adjusted slowly to the light
On the day we drank the juice of apricots
And waited for historians who came in
 Rusty chariots.

We sank that eve into darker dimensions,
Later, with night vision, the ability
To see farther into the shadowlands without
 The blazing sun

Cauterizing communication, burning
The words in our mouths, thanking the darkness for
The cloak under which to share this silent awe,
 This togetherness—

Whatever way it can be in this last
Perfect place, with the volcanos and the fruits,
The dying of fabrics along the river, some
 Reverse alchemy—

The sea god on the waves rolling in on each
Pulse, an ocean turning itself over for
Purification four times daily, to touch
 Me, straw into gold—

All of it, straw into gold, sifted by
A fleece in the river and hung on a tree.
We weren't so innocent not to know its
 Increase, its value—

But also, its limitations, gold back to
Base metals, reconstituted for travel,
To strengthen and transform some
 Other thing elsewhere—

Nothingness for a little while until you
Spoke, remembering the morning when we learned
To ride on his hair, to wade through his danger
 Beyond the shallows—

And come back from our winter to a sandy
Shore of consciousness. Whispers walked us home as
We passed every open space, and the wave god
 Lent his melody.

vi. The Holiday

Now extinction, the price of our rich bounty
This long sorrow. Exacting a penalty
On those who did not meet your childish need,
 Peering through walls

To see into the distance, strike the first
Blow, cast the first glance, to sit and dine
And quietly endure our families and
 Their vicious remarks.

We hung fabric in doorways to keep out the wind,
To block the small parade of ghosts that poured in through
The night with their sacks and supplies, lifting up
 Handles like tombstones.

They marked their resting place in our room,
Phantoms we shared, specters we spawned
From the stories told, abandoned children, the
 Wards of both our worlds—

Occupying an empty space inside the
Labyrinth, the footprint of a cold nursery
For apparitions, and for who we've become,
 Their custodians.

I chose the light, which offered contrast, and I
Moved toward its radiating warmth, but there
Was no joy to stand in, only a better
 Vantage of the dark.

So, I cast myself in stone along the walking
Waters of home, a secret place inside
The juniper and an opening in the
 West bank canopy.

On this side of the island, the coquina
Shells wait low along shore, like him, numinous
In their own sealed space but unable to protect
 Those they pledge to keep.

Though he was brilliant, a good traveler, he
Was not ready to be a guide through the twilight and
Moss-fringed outlines of the city, quiet and
 Untrodden.

Mudflats met hammock, and time mattered less
Than distance, always with the possibility of
A predator lurking in the lowlands or turning
 On its own nature—

But blessings there too, sending us home unharmed,
That we might learn patience and forgiveness
Even for a mentor who failed, who fell asleep
 With us in his care.

vii. Protégé

It was a warm night but not safe for sleeping,
On the streets or otherwise. He did not want
To be lifted to a half-height when he knew
 He was made to rise.

So, he went inside and left an unfinished
Sky, waited for company, but no one came.
That night would not be the one, no lights up on
 The night theater.

Peeled back in layers, with ready blades and
Scarified fingertips, when the investigation
Begins they will find nothing with which to
 Incriminate him.

 Shelves remained empty and the tables crowded.
Cats gathered at the door, and those with names walked
Beside me. But I was late for the lesson,
 And I was followed.

 I entered assembly with a predator's
Confidence, something I learned from you, giving
Incandescent testimony, intrepid,
 My return to home—

 Hidden within the messianic hero,
The self-stinging nature of the scorpion,
Walking past the mentor and ignoring his
 Threats upon my head—

 Looking long into his mouth, sideways down a
Drooping lip, to the back of his throat, revealed
Behind a snaggletooth, lies, such scrutiny
 From the apprentice.

Then, snow in June, silently dropping over
Their ignorance, willingly unobserving,
The assembly emptied at my arrival,
 Me, an inverted broom

Ferreting out information, clearing out
The cobwebs along ceilings and cupboards and
Scattering ideas and ghosts that followed you
 To another rooftop.

Between two cities, watching through blinds,
At evening, I floated forward to confiscate
The archaic inheritance of what I still
 Did not understand—

The perpetual patterns and warring impulses
That brought it to crisis, the predation
Escalating upon a balcony that once
 Overlooked the road

We took to get here and the villages
Left standing after the fires failed. Fewer
Returned than set out, perpendicular to air.
 I did not push him—

But I lured him just the same, past the point where
He could reach, a quarter inch between capture
Or release, and watched him float of his own accord
From the breezeway.

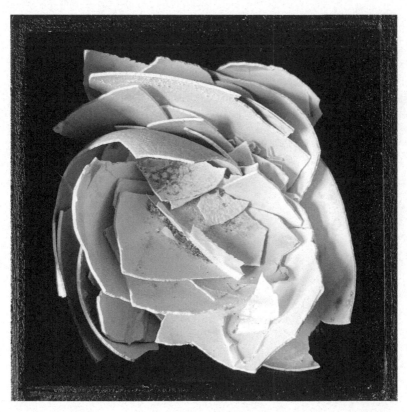

Fig. 17. *Fledglings*

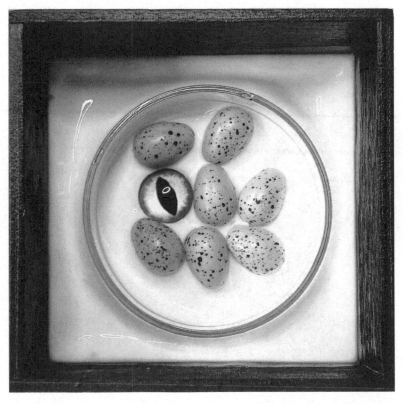

Fig. 18. *The Name for Dreams*

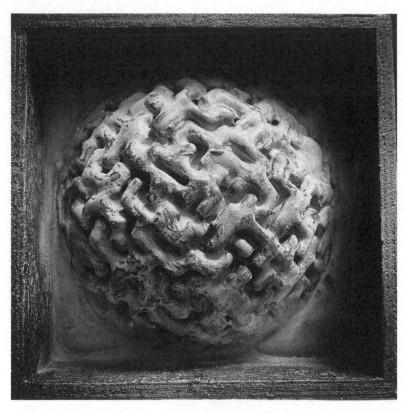

Fig. 19. *Acropolis*

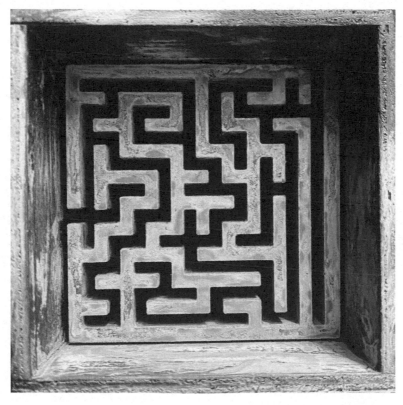

Fig. 20. *Roman Translation*

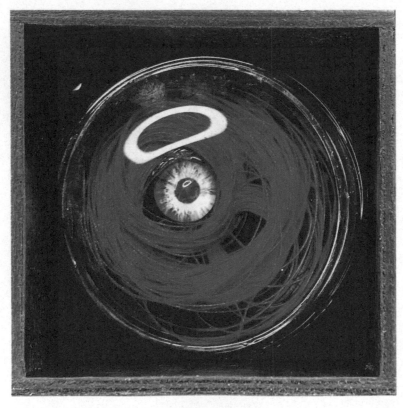

Fig. 21. *Genesis*

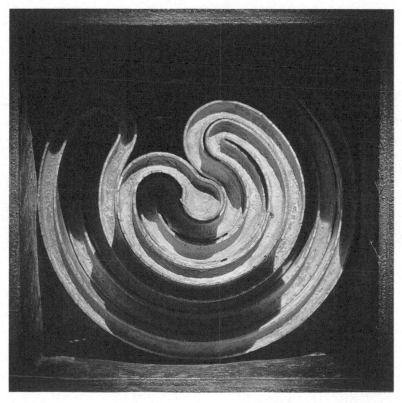

Fig. 22. *The Garden of Asterion*

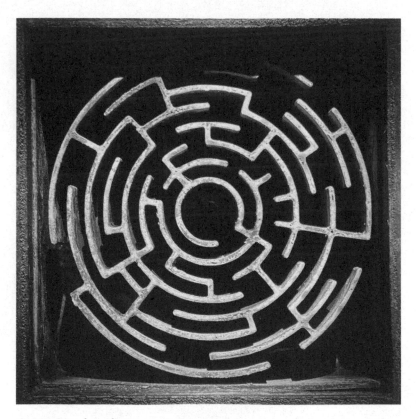

Fig. 23. *View from the Tower*

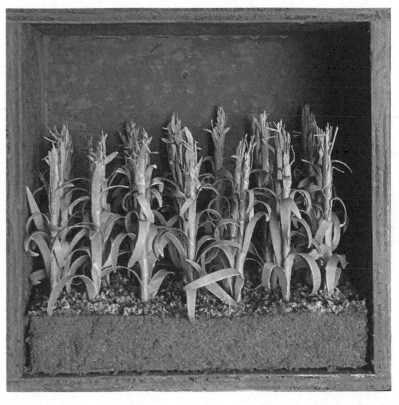

Fig. 24. *Late Season*

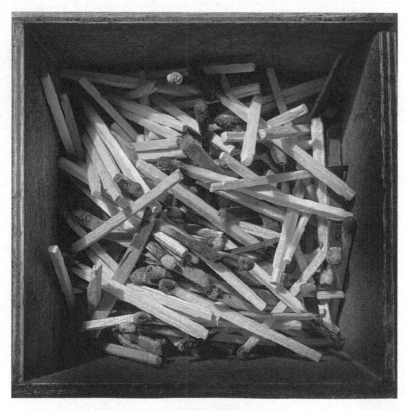

Fig. 25. *Smell of the Holiday*

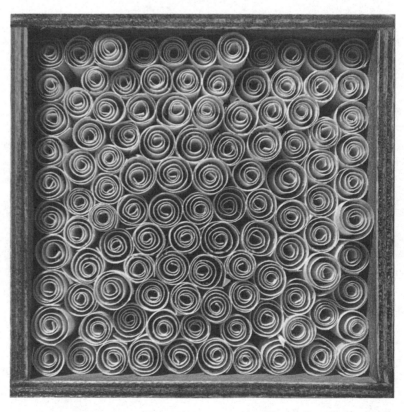

Fig. 26. *Story Stealer Scrolls*

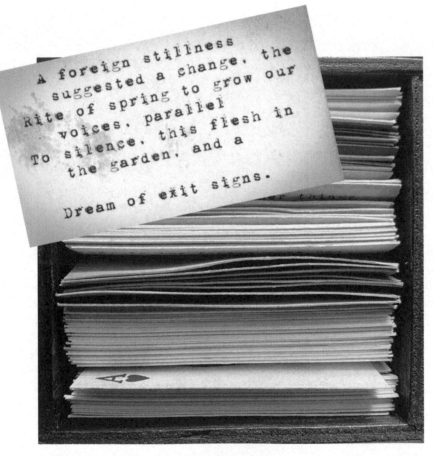

Fig. 27. *Notes & Stanzas* (set 5 of 7)

V. Cartography

i. Lazaretto

Your music sparred with loneliness, whose works
Kept company with me in seclusion, the sound
Of the mournful made bearable, busy the
 Lonely hours pass—

Quarantined inside this dream, insulated
From the terrors outside but longing for a sense of
Solitude, even in such isolation, and more,
 Such violent hands, stilled.

The tiger tamer's daughter, feral at
Daybreak, opened cages on deck while he
Rested somewhere in the foothills, a parrot
 On his shoulder—

Drinking in the thoughts of his seclusion.
Breakers stormed the gates of a bastion unattended,
As channel guardians, angels in wolfskins,
 Boarded cargo vessels.

They watched over this progress, our journey,
Forward on fish fins, shapeshifting in the swirl,
Ocean rising to sky with no horizon by
 Which to set a course.

So, we stood on all fours, noses to the wind,
Waited to catch the scent. He held the mountain,
She held the shore, and we sailed between
 Scylla and Charybdis—

Our breath kept quiet and close, lost in the web
Of the Sargasso. Floating forests sharpened
Our instincts for the wild, created in us
 A hunger for land.

With you in a hall of mirrors where neither
Of us remain, the part of me still trapped with
The only part of you I can remember,
 Past what we can see—

Unfinished avenues, dead ends to a
Sunken threat, pirates on open seas, hostiles there
Who lurked at watery crossroads, something to
 Time well and avoid—

Carrying stones in pockets, knowing the next
Tall tree should we need to run and climb quickly,
To hear or sense the approach of fathers or
 Uncles who find us

In the hush moments of our rooms as we feign
To slumber, to unhear their words and hearken
To starboard, we press curious heads against
 Thin paneled walls.

We look for signs of tension whenever he
Walks into a room, a stranger still after
All this time, a visitor from the mainland
 To our hidden world.

The quantity of twine withdrawn amounted
Altogether to several city squares, cracked
Like a whip, resounded in the distance, mad,
 Hauled up from the kill.

 Agonized, so little patience, so little
Curiosity among the many when there were
The most abundant opportunities for
 Witness or injury—

 Artful, bold, and mischievous, dangerous
The horrid transactions, pursued, wounded, and
Parried, assaulted for some time, the rebound
 Of the screaming cord.

 The clew suspended only to bound forward
Again, indirectly discovering the way
To return, under short sail and little
 Less understanding—

 Lookouts scanning the wide expanse, a different
Air from those engaged in more usual sport,
Bloody possession, and bloody recompense,
 Our fathers to blame—

A xiphos kept as souvenir, sharpened for
The day, red as the twine and the innards of
That which it murdered when more set out to sea
 And fewer returned—

Forward then from solitude and secluded
Introversion with him in our shared tenderness,
Now forced out on wax and feathers into
 Intercourse with the world.

v. After the Funeral

Barred, blocked, then stolen in the night,
Our stories, taken by thieves in half light,
Mostly not-so-distant family, her love,
 And one of seven—

A circle of vultures that moved to descend
On our imminent departure, to claim the
Legacy and crown, a new prince to rule the
 Misbegotten throne.

When council arrives to investigate, it
All comes down to what is on paper, who kneels
Before the false king and who arrives first before
 The funeral ends.

Here, once risen, bathed in melancholy,
Remembering to flip over and tan my
Back in its jaundiced glow, water so black the
 Moon turns it to oil—

Its encircling penumbra finds me sifting
Through a wilted collection, books and scrolls,
Treasures inherited, bequeathed to me by
 Unknown relations.

What fortune has funded me in my very
Forgetfulness, some fortnight, laying arm in
Arm with the past, watching an orb fill with light
 Grow yellow then white?

Morning view of the market out an open
Window, traders in their woven dresses, witnesses
To our morning after, journey with us home. He
 Sits across from me—

Praying to Olympus or the congress that
Gathers in the street around us, some vote that
Will change our patterns and our comforts, deep
 In waking sunbeams—

A sideshow to what matters most, labyrinthine

Evasions to the task at hand. He might have

Known my work in this world was not that for which

 I was conscripted.

 vii. Revisions

Fourteen dates remembered, no one came,

The celebration that ended early as

We walked into the abyss and out on our

 Own ceremony—

Made sacred, your hands around my neck,

Revisions for later life, all inventions.

Who else would remember it that way in

 The nightly telling?

When autumn found us below the hill, I

Ran and you followed. Three months later, at the

Temple, whispers among those assembled there,

 We found each other

Through a miscommunication, you and I,

Your hands around my neck, squeezing my open throat.

You did remember, and they came in time to

 Catch me as I fell.

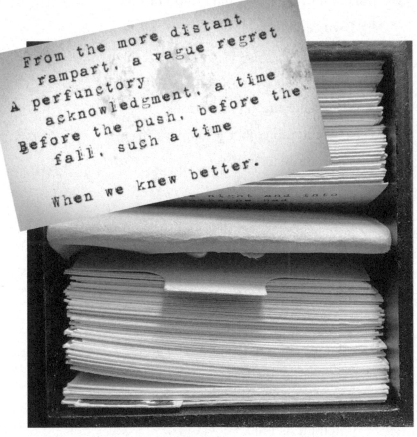

Fig. 28. *Notes & Stanzas* (set 6 of 7)

VI. The Blessing of the Fleet

i. The Night Fishermen

Before he dons the fins and gills he will need
To ride the horses of the hurricane, he holds his
Breath to listen through fog on nights that pass
 Along Neptune's shore.

On the back porch of recent memory, a
Tiny boat rests in camouflage, far from the
Bountiful water and the company
 Of sturdy fathers.

It waits for a man who is sleeping to patch
A broken rib in its body as poles lean long
Against a fence, fashioned for gigs that now
 Defend a fortress.

The young boy remembers the itch and rash
From the unfinished handles and how the man
Never noticed the thread shards because his own
 Hide had calloused over.

The boy is waiting, too, for the man to wake,
To go again into the mudmurky creeks of
Sidewinding waterways to places he finds
 Only in the dark—

On moonless nights, past phantom fish who follow
Lantern's glow, off the bow and shoreside,
Their migrating eyes look up from sandy beds,
 Leeward, silent guides

With permission to seek out the world of men
And the land of boyhood remembered, whisper
Secrets to him and to him again, from the
 Silent world below—

That he might share something of who he is or
Who he was or who he might never become,
Silhouettes in conversation across
 The years of silence.

In confession to the starboard realm, which
Requires sacrifice of sleep, they are now
Granted clairaudience below the quilt of
 Sky spackle on black—

A canvas where marsh birds witness the voices
That carry 'cross tides, his response between two
Worlds with something left, too, for a boy to tell
 And a man to hear—

Some distance beyond the dark, between prow and
Stern to echo back something of what he has
Learned, a collection of collagen and salt
 Saved for this night.

Poling in the blackness, they stir the predawn
Waters with a remedy for the years ahead,
A tale told not as father to child, but as
 Children to themselves.

He comes and waits, Brother of Twilight,
Sibling story stealer, his figure molten
By nightfall, the song he gives, the binder of
 Our inheritance—

An inscription whose repetition makes me
Listen for a god yet to 'waken, his house
Flooded, water we ride 'round the room.
 A vessel unmoored

Sails away on cloudy skies, his face moonlit,
To dream together before the house empties.
He sings to those that can hear, low and broken,
 Anchored to marble.

Falling, we make part of the routine, landing,
Good enough for fighting, comedy ours to
Keep, this performance, our warm-up, vamping
 For a tardy muse.

Charlatans arrive from the lake country, a
Magician, with his silks and fire takers,
There to play, swindle, and make merry after
 Our fantasy failed.

Together we dance and make light these short-
Comings. In daylight, harder to see thieves or
Warnings of red tide. At night, sirens call out
Through open casements—

Whispering ill-advice, of truth traveling
At a distance some lonely road up ahead,
For fear of those inscribing their lives at this
Bench with carving knives.

As the night wears on, a companion at his
Side, he gets older for tomorrow's journey,
Absorbs all the pigment and light now leached from
Portraits on the wall—

Picks up his cane and hobbles away
Satisfied, his vessel at full speed across
Dawn's wet sky, paints his memories of evening
There in stolen hues.

Sister of the Deep reflects in watercolor
His efforts up above, working as I sleep,
By safety of night, knowing each in its time
Until morning—

Wake then to what has been stolen by thieves in
The night, under my breath at rest, listening
To my dreams, a family of shape shifters, my sibling
 Story stealers.

 iii. Slow Storm

My departure instigated his exit,
Longer, slower, more deliberate, the way
Of the sensitive, thoughtful and reflective,
 Even through heartbreak.

Into the blue waters off the tip
Of the peninsula, a cloud moved in
From the east, obscuring the olive groves
 And stoae pillars.

Storm clouds from the era of our grandmothers
Gathered over us, out across the sea,
Mothers from the hills where on the lowest klines
 They'd lounge and listen—

Riddling out the storm, looking for a man,
The mender of cast nets, who lived down by a
Rocky cove. When we were young, and you were lost,
 He came to our house.

Already summer had begun in spring,
Slowing our breath and clouding our reactions,
All day positioned to catch some attention
 Ahead of destruction.

I heard the grandmothers reminding us that
A slow storm brews in each refugee heart,
And what we pick up is what we carry into
 The setting dark.

Return him to night and a harvest of sorrows,
Pack for tomorrow to leave the land of our
Ancestors, exiled to waters that have seen
 Us a thousand times.

As the gates closed, the water rose, but there
Were boats everywhere and something gathering
Air, the world flooding like a tower, melting,
 Collapsing inward.

Navigating the seas of this violent dream,
His whirlpool intentions and his endless need,
I caught a glimpse of us in a broken mirror
 In a wreck off the coast.

Silently floating, seeing myself pass through
A small opening and swim upstairs, I left
My writings and feared those who would
 Misuse my words.

A pregnant oracle formed from sea foam
Over North Rock and moved upward to become
A cloud, a giant sea bass that spoke to me in
 The deepest of voices:

Keep moving, and I kept moving. I can still
Hear her say, *There is a slow storm brewing in
Our hearts,* inside all the refugees of this
 Wasteland, *Keep moving.*

iv. In the Cave of Minnows

The entrance to the labyrinth was a marvel
Of construction. The middle maze, our playground,
Wrapped around the corners of the palace where
 We swept our secrets.

What sacrifice can bring this forward,
Some famine in the stillest hour, that which
Is depleted, hurl it into the world, devote
 Ourselves to its cause?

Perfection called to you like a siren, limited
You by describing you. We cast our spells
Differently, me flying across the water
 Blessing the fishes—

You, inventing an artery that flowed through
Our lives, compromising it, following your
Expositions into the world, seeking
 An opposite.

I wished for loyalty to something greater,
And suffered more for not wanting to suffer.
I moved in it until trodden under, breath
 Held against the wind.

For deification or mortification,
Justice worked in shifts, was tougher than
The disease in that time, breathing once
 And surpassing fear—

At the burn barrel, a humiliation
As my father called me by another name.
I knew the difference even then and that I
 Had more to reckon—

Guilt, fear of death, of what we witnessed, of
Ourselves decoding these events, and of the
Seven and seven who arrived to expedite
 Our absolution.

I gave him a dusty heart, and he returned
An orb of light, bruised but acceptable
Amid the ruins, both of us wyrding our way
 Around devotion—

Stepping into these waters and stepping out again
Somewhere farther downstream, food and flesh,
The temptations that took us, distracted from
 Our true solitude.

Our ideas darkened by sun, many moved as
One in the Cave of Minnows, and we shrank. The
Smaller we became, the more we comprehended,
 Needless of time.

Without time, we were set free, in a right world,
With no reward for remaining in the
Shallows, a hand taking hold, leading us into
 Ravines of passage—

In a right world, our fathers are walking with us
Tonight. In the best moments we are hand-in-
Hand. In the clearing, we are uninjured and
Unburdened.

v. The Second Letter

The second letter arrived from the messenger
Who witnessed our departures through these
Many years, waiting outside of mazes and
Gardens and towers:

Dearest, the shadow of a great bird flies over
The canals as I stare out at the narrow
Alleyways against the lagoon covered in
Early autumn fog.

It is strange to be here without you. I look
Up, and I am blinded by sun. I hear
The crow caw once, then resting again,
Passes out of sight—

And passing, still calls back from below, now in
The folds of some valley where the geese have gone.
Through the campo this morning, the season
Winds itself to sleep.

I think of the cottonwoods back home, singing
Their songs of rain, sipping their last long drink
From deep within the reservoir below,
 Quenched as we were once.

 Apart now these many years, the beginnings
Of our lives seems stretched through the middle, and I
Sit thinking about the center of it all,
 Like our labyrinth—

 Occupying a zenith of youth squandered,
Opportunity, the realm that we have since
Disinherited, once tautly kept between
 Two custodians.

 It ascends above to the land of sky unseen,
A reflection of stars, a heaven once ours,
Now the farthest west of here, flying over
 Ligurian tides.

 As I write, calmed now by approaching night, I think
Not of lift-off or landing but this altitude at which
I soar, just far enough to see peace at
 A safe-enough distance.

Riding the wild currents of air, a ship
Tossed in turbulence, I think of you in the
Time of sunset, but the darkness calls me now
And I must go. Yours.

vi. Archaeology

The homeland comes to mind, an agitated
Pond surface awakened by probing interest,
Looking back, a duel with self, a challenge
 To move on.

The further away, the closer I get,
Steaming vapor on desert roads, my own
Reflection, for all its wavy edges
 Feels more real than focus—

Feels more alive because of the feelings I
Have for it, a realization and relief,
A pending death, the contents of a bladder
 Severed from a goat—

Turgid, with scorpions in his seed, the
Elasticity segmented into dry rot,
Laying like an archaeological dig
 Along a desktop.

There are four ways to go: up, down, slowly, or
By surprise, a spiral of intestine laid
Out like a tunnel or knotted bed linens tied
 To a window gate.

 Counting days by number of dreams remembered,
He shuffled along quilted hallways in his
Wood paneled prison, his moss-covered bedroom,
 His stone edged childhood—

 Made love to wishes in the evening, yellowed
In waning adolescence and gave away
His bed for a reclining lounge as he grew
 Larger in the room—

 Conjured images of soft, curly hair
That peeked golden in the sunlight above the
Low-cut garments on the hard grounds at noon,
 Playthings in daylight.

 He loved the toss of a disc for the reveal,
Of the reach and was happy to be smaller
Than the rest for the vantage it offered,
 His future marks—

Seeing tomorrow in the fineness of
Coming of age beneath his mentor, he did
Not anticipate his own last years, his aged
 Form kneeling to youth—

Did not mean for his expressions to become
His life, his work, his art, but that they have makes
Him long for the next feeding and to keep on
 In some direction

Of depth and solitude, not framed on the wall
Like a taxidermy head, viewed for the skill
He possessed that outgrew his gesture and the
 Beauty of his task.

Obscured by enlargement and viewers who stand
Too close, no matter how they might discard him,
They will know the truth: he wants to dance the dance
 Of swirling abandon

In autumn windstorms, to bounce on the branch
Of the many-armed olive in the gold dust
Of desiccating leaves, to look again upon
 The face that he loved.

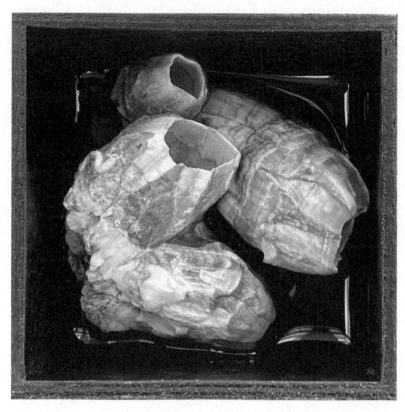

Fig. 29. *Tethys*

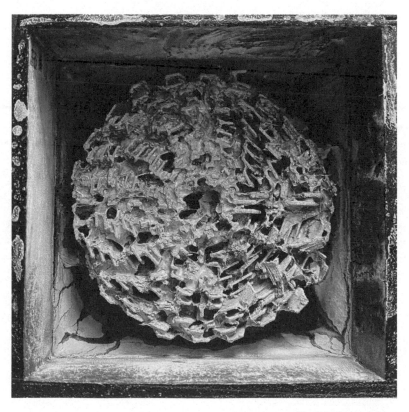

Fig. 30. *Gorgon's Nest*

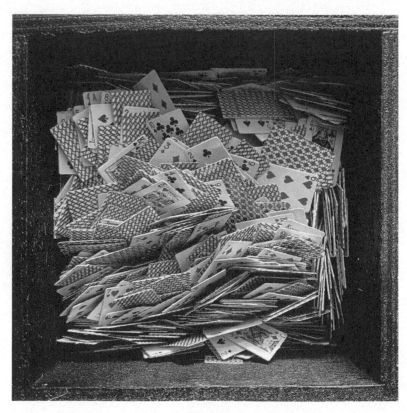

Fig. 31. *Candia*

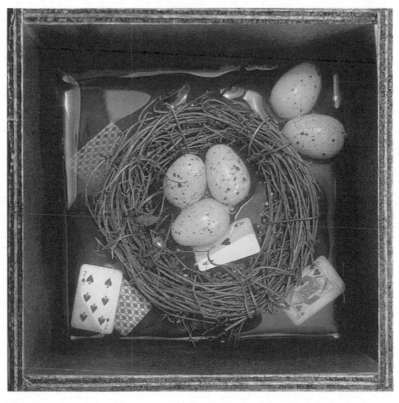

Fig. 32. *The Flood*

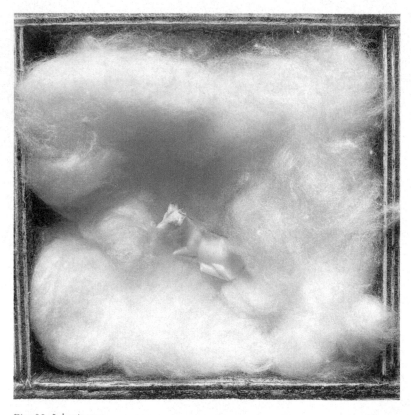

Fig. 33. *Inheritance*

124

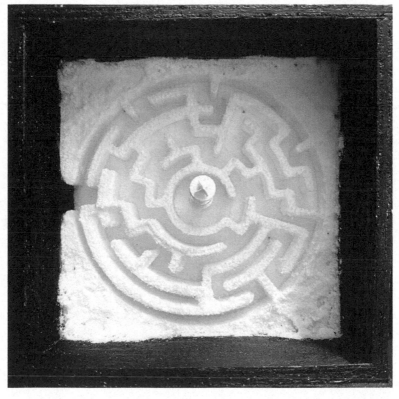

Fig. 34. *Winter's Test*

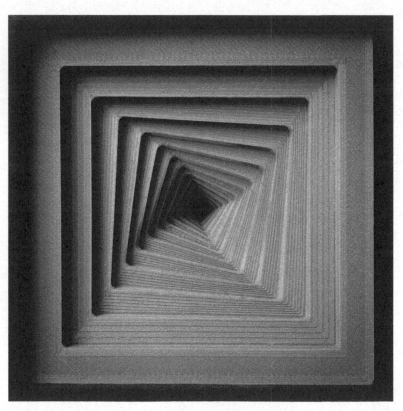

Fig. 35. *The Fall*

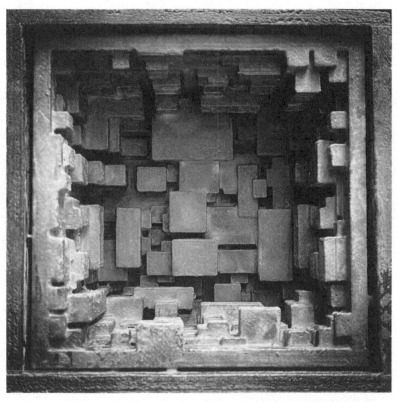

Fig. 36. *The Copper Palace*

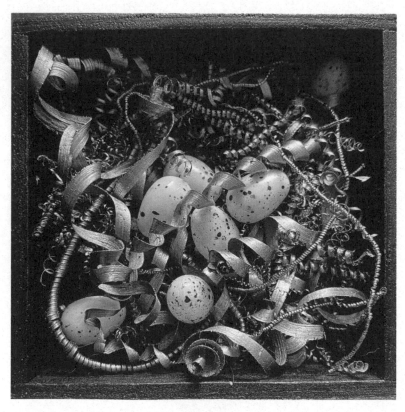

Fig. 37. *First Seven*

Fig. 38. *Preservation*

In the future I will think
of this along
A cartography of where my
hands have passed.
Maps drawn on silk, hidden
in coat pockets and

Of our quiet stealth.

Fig. 39. *Notes & Stanzas* (set 7 of 7)

VII. The Name for Dreams

i. The Rain Room

In the rain room, I rise to the sound of horse

Hooves on terra cotta tiles, the percussive

Romp of equine angels on red rooftops. Why

 Has he come in this way?

So out of place, trying hard to find sleep, sleep

Redirecting me onto a pathway of

Opposites. If I don't face it now, it will

 Be lost on the light.

Out of breath for him, I wait and remain in
Hiding to offer Loyalty a drink when
It comes, teetering, precarious, and
 Fragile, to the well—

Attempting to outmaneuver the current,
Perchance to collapse in a desert far away,
To go on running again in service to
 That which I loved best—

Not to melt from sky, too soon plunging into
The sea. He still cannot see, still cannot hear,
Is listening too hard for what he wishes for
 Me not to say—

What he wishes me to be or what he
Wishes to now be offended by, thinking
Of how we left the matter and how I
 Continued in exile—

Hearing him explain home to me so far from
The homeland, letting it pass,
Understanding that we are all coming
 Up for air somewhere.

In the rain room, the smell of wet canine mingles
With the after-aroma of smoky piss.
Electricity spins a web across the damp earth,
 Mixes with leaf rot.

Dragonflies lower themselves like a curtain.
Along the shore, the old men begin to reel
In their kites. Rain is coming to the rain room.
 Rain is coming.

ii. Dreams of War

I awaken in puddles of sweat, within the
Latticework of a web, shed a cocoon of
Dirty silk, and battle my way out from under
 A mosquito net.

Peeling myself from its adhesive embrace,
I dart forward, caught in an updraft. We fly
Like this, you in your cauldron of rain, me, tied to
 The tail of a kite.

The outline of our quieter intentions,
Showered under golden skyways, sits on a
Balcony overlooking misty peaks, listening
 To birds and frogs.

Either they awaken, or they make their last
Protest to dawn, revelers when the festival
Is done. Morning insists on ending the night,
 Changing the guard—

And the reluctant and defeated, through sheer
Exhaustion, depletion, or besting turn in for the
Day, leaving light to the light dwellers, while pear
 And fig still sleep.

A cliff resting on its back, mountainous hair
Flows into the sea, points a breast heavenward,
The earth of Corfu laid bare between the clouds,
 And the day passes.

Kumquat groves fulfill a prophesy from the year
Before, jewels along his embankment, ribbon roads
Thread 'round his body, the moistness of his fields
 And terraces, loamy.

Ruffled, they dress me for evening. Muddy roads
Meet white limestone, water, and rain, a fertile
Crescent full of biting insects and singing
 Toads in the tall grass.

Even the seagulls go quiet as an
Evening downpour bends afterthoughts of
Light to sound, letting the veil of dark dial its
 Sonic symphony.

At dinner time, we are called. We go. It's the
Same in each place, boiled cabbages and cakes baked
In clay ovens, the open doors of dwellings
 Wafting rosemary.

I woke from a dream that I was in a foreign
Port, shoes left on a dock, boarded a metal
Bird, flight, no sandals, wrong flight, screaming to stop
 The avian roar—

No sandals, bare feet, an empty flight, thrusting
Toward unknown jungles. The same image
Again the next evening, I didn't notice I was
 Going to his war—

Didn't look at the pier where I boarded
The wrong bird, but I smelled my father nearby,
And on the day after that, another afternoon
 Was laid to rest.

I need to urinate and fight to break free
Of canopy nets, wrestling fabric in the
Contours of low light and wake once more to
 Thoughts of my father.

Soaked in my own sweat, I recognize
That I smell like him, and I share his dreams,
To come this far to find that out, to notice
 Droplets on clover.

Thoughts of you perspire through evening, something
Newly found and newly lost, something more to
Miss and mourn, you across the world living
 In my yesterdays—

How suddenly it conjures you, makes my
Departure all the more precious, to take this
Image, shutters fastened, and step into the back
 Of a tinted ride—

Slip quietly down the mountain, then turn!
The balconies fill with well-wishers who wave
Goodbye, holding small dogs up to their chests,
 Shaking them in farewell.

Back at sea level, I wish you could see it
This way, not through sleepless and bloodshot eyes,
Looking for you in all the faces as a moon
 Looms large, cresting over.

Below the mountain, stopping at roadside, it comes,
Rising and magnified. I have only seen
This moon once, and yet here it is once again
 After all this time—

Showing the same face it showed us then, keeping
Us in its memory, hearing you over
The water, *I wish you'd stay. I don't want to*
 Leave. I have to go.

iii. Flight

Centuries will pass before we go quietly and
In peace, follow custom, bequeath our letters
To the curator of our constellations,
 Some new archivist—

Who, because we produced nothing of our own,
Must be some great child of Ariadne who
Will once again thread a way through this
 Winding labyrinth:

What is broken in him will be broken
In me. What is broken by the sun
Will return him to the father, and his
 Brother will offer a hand.

 My father was afraid to fly, unfathered and
Leaving vague instruction. What was there but
Fly to the sun, fall featherless/fatherless
 Into the sea?

 Sculptural murders, the inventions of
Daedalus, always loyal to that which
Exploited him for his own ambition, in search
 Of elusive praise—

 And the winner of war, the king willing to
Sacrifice the most of his own young men, with
Us left alone in a prison we thought our
 Own secret garden—

 Icarus again every time turbulence
Jogs my memory of all the things longed for,
Things regretted, catalogs of how much there
 Is always to lose—

Remembering your tempests and rages, yet
Delighting in the billowy way a feather
Will lift itself from the floor when left alone
 With the swirling wind.

 iv. In Memoriam

You came again in the night, the one who has
Been my prodigal avatar, the one who comes
But never stays, evaporates, is gone, *What*
 Is broken in him—

Will happen again in another time,
Your name elusive to me, your profile a
Consolidation of all of those I've known,
 Loved, or longed for—

Without their ache in return, *will be broken*
In me. You, of narrow hip, without age,
But my age, whatever that may be—we have
 Grown old together

In my imagination, in the night theater,
You have to dig deep. The key to what comes next
Has always been lost in your own hand,
 My consort, clenching—

My secret and yours, an Aster or a

Theseus, a father, a Daedalus, who'll

Finally, and properly, see it in a way

 To bury your father.

We cannot wait for the day to end, to find

Each other in the after-hour curtain of rain,

The pages of our books dampened, the

 Passages blurred

To mean something more than before. We rush to

Our berth in a hurry to exhaust ourselves

Into evening, in such isolated bliss,

 Knowing, recognizing—

Then wake on a ripple, not yet whole,

Putting back pieces, in/different order,

Yet retain our names as they were written

 Upon the ledger of the deep.

v. Daedalus

Each, called by their proper names, present amid

Extraction, those we knew and those intruded

Upon, what is repaired in the son shall be

 Absolved in the father.

Without him each night, I will remember this:
The blessing of the fleet, a foreign stillness,
Cousins to nostalgia and melancholy;
 The passing lanterns

Of the night fishermen who poled and prayed
To hook a dream or spear a light under the
Suggestion of stars, once crossed, crossed again,
 Sewing up the sky;

Of treasures in the garden and passing stories,
Gone as we gathered wax and feathers, bending and
Untelling the tale, the work again commenced
 Soon as it is told;

His unscrupulousness, inventing past
Reason, past the point of no return, past what can
Be known, to fashion a prison and an escape with
 You at the center.

My father was afraid to fly. My father
Was a sailor. He invented the first sails
That outran the fleets of Minos, a harness
 For the wind—

A blistering sun that left marks on his children.
He built this labyrinth and pushed me from a
Tower. He hoped that I would fly, but he
 Miscalculated.

In the future I will think of him along
A cartography of where his hands have passed
And of his quiet stealth, the marks on his fingers
 Like the marks on mine.

Father, heliotrope, turn toward sky.
Blister the children and build this labyrinth.
Let gravity claim its reward, for the wind,
 The reflection of

The sun on the waves, for the fall, the salt on
My lips, the kiss of deep blue water. Let what
Is broken in him break open in me, for
 These ships we have lost.

vi. Icarus

Our stories tether us still, one for each feather
We gathered, not meant for sky but for
Desiccation, each now a spell we cast to the ground,
 Adding to leaden losses.

We touch in our minds, turning tulips in the
Distance, this vision afforded to us with
Wanting across water, hitching rides over
 Downward currents, soars—

Since childhood brought us this, the ability
For lift-off, which now serves us most when we need
It least, carrying us in its chariot,
 Inventions in peace

Unable to rise to the challenge of war, or
Creations of war unable to rest in peace.
We were not trained for their use in those times,
 For his dreams of flight—

Swimming against the ground, kicking up dust
In our futility, with no power to free
Ourselves, from our countries, our keepers, or the
 Distant call to arms—

From our fathers, outpacing us, with a gift
That is a wound that is a gift, that is
Another wound, kidnapped, imprisoned,
 Held too close.

The meaning of wings offers no help, even
With all this ability and the sudden
Potential, our feathers loosened by sea, our waxy
 Togetherness

Melted by sun, flying too near to each, always
Unguided, our fathers out ahead, not
Looking back. We plunge into ill-preparedness,
 Intoxicated—

Hyper-fascinating along the air currents,
Forgetful of the destination but leaving behind
Ideas sown together for a harvest inside
 Of future dreams.

vii. Asterion

We met under threat, in the outlines of
Punishment, no cure for that which cursed our kind.
In an era of fear and misinformation
 We stood alone.

Before we understood what we were,
We knew its consequence, and we showed
Our reticence to look at it in the light,
 Romanticizing

It in obscurity, the blurry edges,
More compelling than definition, prison
More ours than freedom, you and
 I enshrined in stone.

The Venice I'm remembering then was Crete, the
One at the end, the sweetest, when you have the
Sweetest one beside you, when he pores into you,
 Studies and learns you—

Your champion through the ice-melting season,
So young and old. But now it presents a
Memory, a dream of once, when presiding
 Over our arrival—

I learned how many sips of something bitter
Was tolerable between tastes of sweet. After
Travel, the silence and transition with
 What is not yet said—

And the language in between. He taught me that
Morning which was which, how to choose and be
Chosen, to listen from the margins of what
 Is unspoken.

In a right world the two of us are listening

That way again, canceling the debt of

All that accrued in those briefest years of our

Silent communion.

Fig. 40. *Cause and Effect*

Fig. 41. *Call to Prayer*

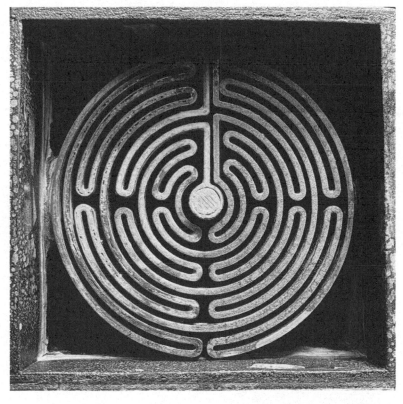

Fig. 42. *Circuit Chartres*

Fig. 43. *Riptides*

150

Fig. 44. *Cave of Minnows*

Fig. 45. *Clew*

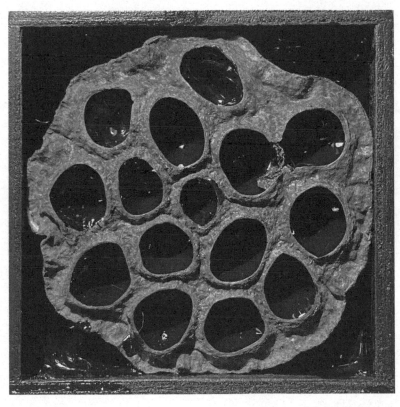

Fig. 46. *The Lagoon*

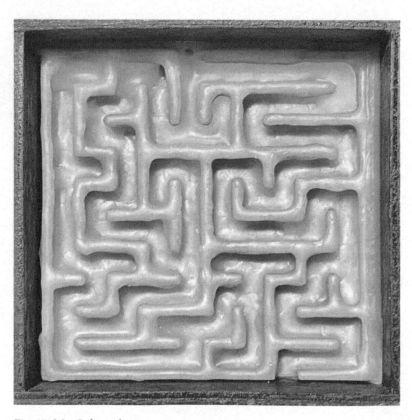

Fig. 47. *Wax Labyrinth #2*

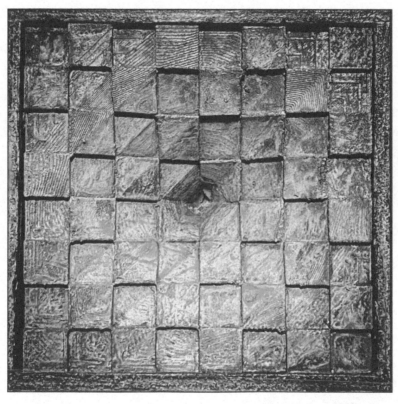

Fig. 48. *Scarifications*

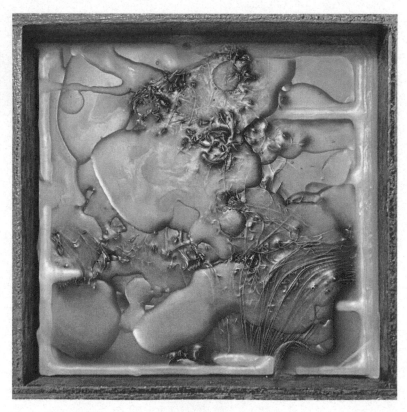

Fig. 49. *Constellations in Wax (il Toro)*

Epilogue: The Things I'll Miss

A foreign stillness suggested a change, the
Rite of spring to grow our voices, parallel
To silence, over the pillars of Knossos,
 A failure of flight.

Sometimes I think about the things I'll miss: the
Pink sands and waters of Elafonisi,
Sunset from the harbor tower, his warm breath
 Over my shoulder—

Then stop and remember it all: the
Thunder above, great clouds turning, the asters,
Scattered through goldenrod, the metronome of
 My footsteps on the ground—

Thunder to the snails and the ants, the small
Indescribable rodents burrowing and
Scurrying in tunnels along the shore, the
 Others that walked

The corridors of this place, how much light I
Allowed into the morning, a meter for
How I felt, the death bloom of the agaves
 That marked the path—

Giving their energy to the future, the
Faithful pigeons on the cliffs of Mykonos,
Gifts you left by the tower, and the rosemary
 (For remembrance).

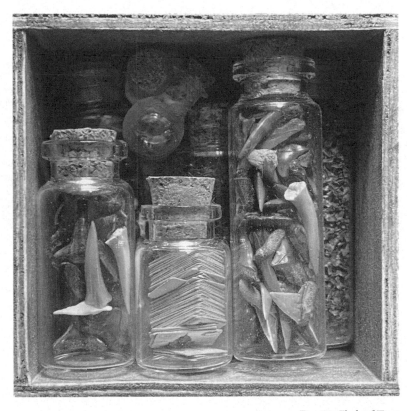

Fig. 50. *Flesh of Time*

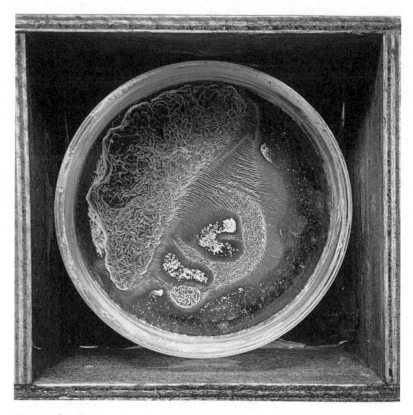

Fig. 51. *Slow Storm*

Notes on the Installation Art

The content of the installation art represents a correspondence between mythological figures and is comprised of written fragments, artifacts, ecofacts, and ephemera. These are expressed within a series of wooden apothecary drawers, approximately half of which are featured in this volume and, along with the other half, are showcased in live gallery exhibitions. The physical installation also features multiple drafts and fragments of the written content of this book.

There are purposeful and accidental anachronisms within the collection, and a linear concept of time or a binary understanding of character isn't useful to adequately relay the immortal logic of these archetypes, especially as they pass through spatial and temporal transmutations. The epistolary and creative correspondences between Ikaros and Asterion are paradoxical in this way, creating an expanding matrix of time and space, mapping varying constellations of gender, and amplifying tensions between metaphors of anthropomorphism and zoomorphosim.

The enigmatic notes and cards are primarily attributable to Ikaros (Icaro, Icarus), though other authors are evident. The artifacts, ecofacts, and art, on the other hand, appear to be the sole expressions or collected items of Asterion (Asterius, Aster, Minotaur), some of these representing the relics of other characters and events that perhaps shaped the adolescent intrigues of the main players.

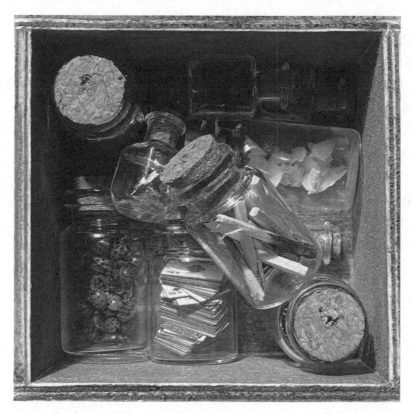

Fig. 52. *La Nostra Fortuna*

Notes on the Text

"Homesick for homeland, Daedalus despised Crete . . ." as quoted in the front matter is from Ovid's *Metamorphoses* after the translation by Rolfe Humphries. I have made a few further translations/substitutions in the text, replacing "hated" with "despised" and changing the phrasing of "surely the sky is open" to "still, the sky is before us," keeping the meter intact.

References to the tales of Icarus and Daedalus as well as to Pasiphäe, Minos, the Minotaur, Ariadne, Theseus, and other myths involving Daedalus are taken primarily from Ovid's *Metamorphoses* and the *Bibliotheca* of Pseudo-Apollodorus. Nowhere do any of the tales explicitly connect Icarus and Asterion (the Minotaur), but through Daedalus, they are always once removed.

I have concerned myself with a speculative mythology that assumes a shared youth for Icarus and Asterion on Crete, presuming to connect the House of Minos to the private affairs and family of Daedalus. I have endeavored to complicate the otherwise binary, rigid, and often minimal representations of these two mythologies, which, throughout Western literature, frequently renders the Minotaur and Icarus simply as a monster and a child of hubris, respectively. I have sought to overwrite those interpretations and reinvest in the metaphors, to complicate their journeys here with a messier coming of age for both.

The poems "Prospect" and "Clew" reference Herman Melville's notes and research for *Moby-Dick*, the many newspaper clippings and encyclopedic sources he cites that relate to the whaling industry and which he lays out before the novel begins. The descriptions of harpooning a whale, in my imagination, echoes Theseus's pursuit of the Minotaur, and I used a form of obscuring (blackout or erasure technique) to isolate action within these accounts and then thread the sequences together.

"Waning" nods to Robert Louis Stevenson's *Treasure Island*, "Call to Prayer" to Maya Angelou's "To a Man," and "Story Stealers" to Alfred Noyes's "The Highwayman."

"You have to dig deep to bury your father" is a Romani proverb that appears as interjections within the poem "In Memoriam." I owe the quote to Dr. Clarissa Pinkola Estés. It speaks to me of an underlying archetypal endeavor within the process of reclaiming a sacred and detoxified masculinity, one of the great heroic challenges of the male psyche. Like Ariadne's clew, it is a thread that runs throughout the poem as well as the totality of *Still, the Sky*. I also pay homage to Dr. Estés in this same poem and in the poem "Oracle" by loosely referencing her quote, "what is broken in the father, will be broken in the son." This quote, from Dr Estés's poetry, has guided me in relaying the relationship between Icarus and his father, Daedalus, and between Asterion and his father, Minos.

Though I make only an oblique reference to Joseph Brodsky, I owe many connections between Venice and Crete to his *Watermark: An Essay on Venice*, which also directly references the mythology of Daedalus as well as the Minotaur and his

labyrinth. I could not have written what I have without some deep groove in my psyche etched upon by his statement that "Every surface craves dust, for dust is the flesh of time . . ." which is invoked in Fig. 50.

A note about the verse: the stanzas are modeled after a Sapphic styling with a flavor of Aeolic verse, but the cadence is its own in terms of where accents fall and how that shifts throughout. I was attracted to the Sapphic effect for the strength with which a line begins on a double hit and the way a stanza finishes on a quick clip. Its strong melodic (and often melodramatic) insistence seemed to match the young and volatile Icarus and Asterion while the classicism lends a patina of immortality.

Fig. 53. *Nesting Tube Lights*

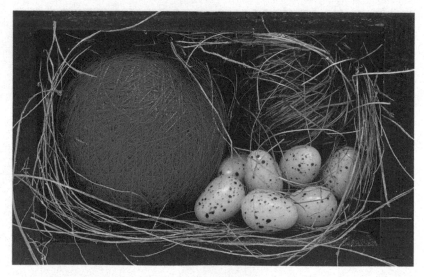

Fig. 54. *The Archives of Asterion, Nest*

Acknowledgments

This work is the result of several fellowships, residencies, and commissions that I was fortunate to take part in between 2018 and 2020, including a Back Apartment Residency in Saint Petersburg, Russia (a program of CEC ArtsLink); a fellowship from the Center for the Arts at Wesleyan University in Connecticut; a fellowship in theater from the Bogliasco Foundation in Liguria, Italy; and as Artist-in-Residence at the Ace Hotel New York. These periods of intense focus resulted initially in material created for *Ikaros*, a site-specific theatrical work commissioned by La Jolla Playhouse for the 2019 Without Walls Festival in San Diego, California, which then became an art installation and poetry manuscript during my time as the Creative in Reference at Olin College of Engineering in Massachusetts.

The manuscript found its final form during the pandemic in correspondence with *The Archives of Asterion*, an interactive art installation that was developed in tandem with the writing. I owe gratitude to Bennett C. Taylor, Arwen Sadler, Jasper Katzban, Julia Benton, and Lauren Anfenson, who contributed to the research, story development, and visual and digital artwork for *Archives* and for this book.

Many thanks to my editor, Anne McPeak, and to the following readers who took the time to work with me on the manuscript and offer editorial suggestions: Jonathan Adler (who also contributed to research and development), Shannon Jowett,

Marissa Nielsen-Pincus, Zach Morris (who also contributed text to *Ikaros* for the theatrical production), and David Mancini (who generously volunteered his time in San Diego for *Ikaros* and to this manuscript).

I am indebted to Dr. Clarissa Pinkola Estés and her Institute for Archetypal and Cross-Cultural Psychology, which has guided me and my work—how I access my creative life and how I care for it.

I am likewise grateful to my long-time co-directors Jennine Willett (along with Zach Morris) and to my collaborators within Third Rail Projects and the Global Performance Studio. I am blessed with an embarrassment of riches in those I have been engaged with in creative communion.

The following have also enabled or shared in stations of this process and imprinted upon the work: Susana Aho (who helped me conceive of the idea of ghost custodians); and Renata Zhigulina, Daria Karpova, Anastasia Nesterova, Marta Luné, Maxim Mityashin, Mary Madsen, Justin Lynch, Sean Hagerty, Taylor Hollister, and Andrew Broaddus, who all took part in creative projects related to this work.

Gratitude to the following individuals and institutions who have supported me in these processes: Edward Rice, Joshua Dutton-Reaver, Brittany Crowell, Joshua Gonzales, Tara Ocon, and Third Rail Projects; Susan Katz, Jane Lombard, Simon Dove, Lizaveta Matveeva, and CEC ArtsLink and the Art Prospect Festival; Show Consulting School and the New Stage Aleksandrinsky Theatre in St. Petersburg, Russia; Fiona

Coffey, Rani Arbo, and the Center for the Arts at Wesleyan University; Laura Harrison, Ivana Folle, Alessandra Natale, Arielle Moreau, Valeria Soave, Rita Abbis, Sara Bozzo, Luigi Crovetto, Raffaella Folle, Daniela Poggi, Franco Romeo, Danilo Taffurelli, Fabio Toracca, and the Bogliasco Foundation in Italy and New York; Steven Kaisser, Marie Van Ersel, and Ace Hotel New York; Sara Hendren, Debbie Chachra, Kristin Casasanto, Benjamin Linder, Sharon Breitbart, and the Sketch Model team at Olin College of Engineering; Christopher Ashley, Teresa Sapien, Samantha De La Riva, Gabriel Greene, Eric Keen-Louie, and the artistic and production departments at La Jolla Playhouse.

Finally, I am grateful to my family, both given and chosen, who have shared so many of their own stories with me over the years. My love of mythology and theater have naturally sprung from this rich inheritance. In particular, I remember listening to my dad's stories, which he shared with me while showing me how to fish for flounder by lantern light, poling along the black water creeks of the Tolomato River. "The Night Fishermen" is for him.

<div align="right">

Tom Pearson

New York

</div>

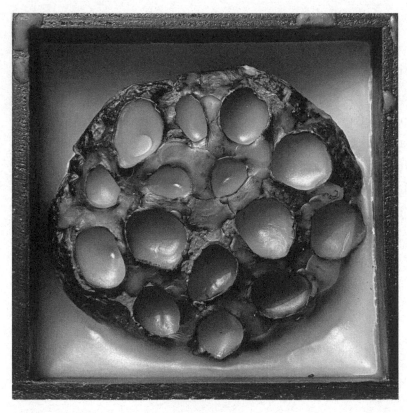

Fig. 55. *Lotus Labyrinth in Wax*

Fig. 56. *Bee Mausoleum*

NOTES &
STANZAS
1-139

DREAM OF
EXIT SIGNS

BEF
R

AR
C

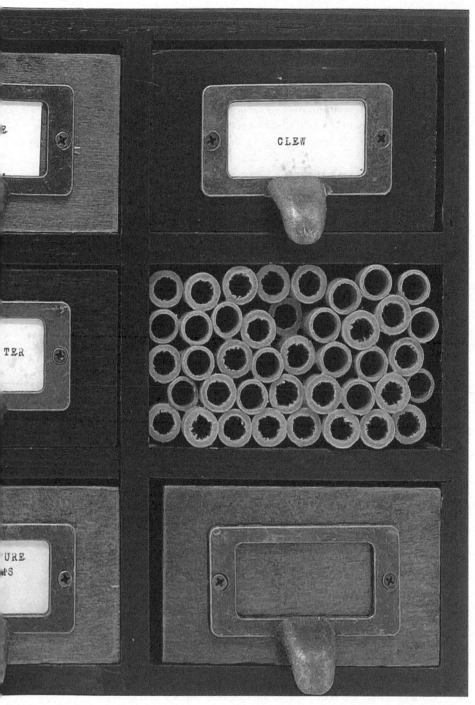

Fig. 57. Drawer set from *The Archives of Asterion*

List of Figures

1. *The Archives of Asterion, Notes & Stanzas* 255-363, wood and metal drawer with printed parchment and wax, p. vi

2. *The Archives of Asterion*, wood and metal apothecary drawers, mixed-media, p. x

3. *Notes & Stanzas* (set 1 of 7), wood box, parchment, p. 16

4. *Seed of Minos,* wood box, scorpion, resin, glue, p. 31

5. *Notes & Stanzas* (set 2 of 7), wood box parchment, p. 32

6. *Notes & Stanzas* (set 3 of 7), wood box, parchment, p. 50

7. *Gardener's Choice,* wood box, milkweed seed pods, p. 63

8. *Hall of Mirrors,* wood box, mirror tiles, plastic, resin, p. 64

9. *Obfuscation,* wood box, filament, oxidized copper, p. 65

10. *A Perfunctory Acknowledgment,* wood box, red thread, beeswax, rubber bands, waxed nylon, p. 66

11. *Prognostication,* wood box, oxidized copper paint, p. 67

12. *The Dig Near Lake Maggiore,* wood box, fossils, p. 68

13. *The Dive at Lago di Ripola,* wood box, fossils, p. 69

14. *Wax Medusa,* wood box, filament, beeswax, p. 70

15. *Wax Theseus,* wood box, plastic, beeswax, p. 71

16. *Notes & Stanzas* (set 4 of 7), wood box, parchment, p. 72

17. *Fledglings,* wood box, goose eggshells, p. 86

18. *The Name for Dreams,* wood box, glue, petri dish, plastic eggs, glass eye, p. 87

19. *Acropolis,* wood box, filament, oxidized copper paint, p. 88

20. *Roman Translation,* after a design by Jasper Katzban, wood box, filament, oxidized copper paint, p. 89

21. *Genesis,* glass petri dish, red thread, glass eye, p. 90

22. *The Garden of Asterion,* wood box, filament, oxidized copper paint, p. 91

23. *View from the Tower,* wood box, filament, oxidized copper, p. 92

24. *Late Season,* wood box, wire, paper, foam, p. 93

25. *Smell of the Holiday,* wood box, spent matches, p. 94

26. *Story Stealer Scrolls,* wood box, rolled parchment, p. 95

27. *Notes & Stanzas* (set 5 of 7), wood box, parchment, p. 96

28. *Notes & Stanzas* (set 6 of 7), wood box, parchment, p. 104

29. *Tethys,* wood box, purple barnacle cluster, resin, p. 120

30. *Gorgon's Nest,* wood box, filament, oxidized copper, p. 121

31. *Candia*, wood box, miniature playing cards, p. 122

32. *The Flood*, wood box, miniature playing cards, resin, plastic eggs, wood vine, p. 123

33. *Inheritance*, wood box, cotton, plastic, p. 124

34. *Winter's Test*, after a design by Jasper Katzban, wood box, filament, silicone, paper, p. 125

35. *The Fall*, after a design by Jasper Katzban, wood box and wood filament, p. 126

36. *The Copper Palace*, after a design by Jasper Katzban, wood box, filament, oxidized copper, p. 127

37. *First Seven*, wood box, metal shavings, plastic eggs, p. 128

38. *Preservation*, wood box, glass tube, cork, matches, straw, p. 129

39. *Notes & Stanzas* (set 7 of 7), wood box, parchment, p. 130

40. *Cause & Effect*, wood box, filament, resin, plastic, white paint, p. 147

41. *Call To Prayer*, wood box, plastic, oxidized copper, p. 148

42. *Circuit Chartres*, wood box, filament, oxidized copper, p. 149

43. *Riptides*, glue and glass, p. 150

44. *Cave of Minnows*, glue, paint, and glass, p. 151

45. *Clew*, wood box, red thread, p. 152

46. *The Lagoon*, wood box, dried lotus pod, resin, p. 153

47. *Wax Labyrinth #2*, wood box and wax, p. 154

48. *Scarifications*, after a design by Jasper Katzban, wood box, filament, oxidized copper, p. 155

49. *Constellations in Wax (il Toro)*, wood box, filament, poured wax, p. 156

50. *Flesh of Time*, wood box, liquid skin, shark's teeth, glass, cork, playing cards, dust, p. 159

51. *Slow Storm*, glue, paint, and glass, p. 160

52. *La Nostra Fortuna*, wood box, glass, cork, ladybugs, playing cards, cat claws, doves of sand dollars (hearts of Clypeasteroida), spent matches, p. 162

53. *Nesting Tube Lights*, wood box, cardboard nesting tubes, LED candles, p. 165

54. *The Archives of Asterion, Nest*, wood, straw, string, plastic, p. 166

55. *Lotus Labyrinth in Wax*, wood box, dried lotus pod, wax, p. 170

56. *Bee Mausoleum*, glass petri dish, bees, p. 171

57. Drawer set from *The Archives of Asterion, East Wing*, wood apothecary drawers, mixed media, cardboard nesting tubes, straw, red twine, plastic eggs, p. 172-173

Tom Pearson, Self-Portrait, Moscow, 2018

About the Author & Artist

Tom Pearson works in theater, dance, film, poetry and multimedia visual art. He is known for his original works for theater including the long-running, off-Broadway immersive hits *Then She Fell* and *The Grand Paradise* and as a co-founder and co-director of the New York-based Third Rail Projects and Global Performance Studio.

Tom has been named among the "100 Most Influential People in Brooklyn Culture" by *Brooklyn Magazine* and has received numerous accolades for his work, including two New York Dance & Performance (BESSIE) Awards, a Kingsbury Award in writing from the Florida State University, and several international film festival awards for his collaborative experimental short film, *The Night Garden*. He has also received commissions from Lincoln Center for the Performing Arts, La Jolla Playhouse, Jacob's Pillow, Folger Shakespeare Library, Lower Manhattan Cultural Council, Danspace Project, Hong Kong Youth Arts Foundation, and more.

Tom has received fellowships and artist residencies from: CEC ArtsLink (Russia); The Bogliasco Foundation (Italy); the Center for the Arts at Wesleyan University (USA); and Olin College of Engineering (USA); among others.

He is the author of two books, *The Sandpiper's Spell* and *Still, the Sky*. More information available at his website and on social media at: tompearsonnyc.com and @tompearsonnyc.

Made in the USA
Columbia, SC
29 May 2022

61074884R00104